BIRD

BRAINS

The Intelligence of Crows, Ravens, Magpies, and Jays

BIRD

BRAINS

CANDACE SAVAGE

SIERRA CLUB BOOKS
SAN FRANCISCO

To Keith

The Sierra Club, founded in 1892 by John Muir, has devoted itself to the study and protection of the earth's scenic and ecological resources—mountains, wetlands, woodlands, wild shores and rivers, deserts and plains. The publishing program of the Sierra Club offers books to the public as a nonprofit educational service in the hope that they may enlarge the public's understanding of the Club's basic concerns. The point of view expressed in each book, however, does not necessarily represent that of the Club. The Sierra Club has some sixty chapters coast to coast, in Canada, Hawaii, and Alaska. For information about how you may participate in its programs to preserve wilderness and the quality of life, please address inquiries to Sierra Club, 730 Polk Street, San Francisco, CA 94109.

Library of Congress Cataloging in Publication Data

Savage, Candace Sherk, 1949-
 Bird brains : The intelligence of crows, ravens, magpies, and jays / Candace Savage.
 p. cm.
 Includes bibliographical references and index.
 ISBN 0-87156-379-7
 1. Corvidae. 2. Corvidae--Psychology. 3. Animal intelligence
I. Title.
QL696.P2367S28 1995
598.8'64--dc20
 95-1169
 CIP

Editing by Shelley Tanaka
Front jacket photograph by Art Wolfe
Back jacket photograph by Hannu Hautala
Design by Tom Brown (WORKSHOP)
Design Associate Ron Koslowski
Species illustrations by Randall Watson
Maps by Anna A. Belluz
Printed and bound in Singapore by C. S. Graphics Pte. Ltd.

10 9 8 7 6 5 4 3 2

Quotations from *Ravens in Winter*, copyright © 1989 by Bernd Heinrich, are reprinted by permission of the author and the Sandra Dijkstra Literary Agency.
"The Raven and the Hunter," p. 104, is reprinted from *A Kayak Full of Ghosts*. Copyright © 1987 by Lawrence Millman, with permission of Capra Press, Santa Barbara.
The illustration on p. 9 is reproduced by permission of the British Library. Royal 12.CXIX -folio 43.
The photograph of *The Raven and the First Men* by Bill Reid, p. 40, is reproduced courtesy of the Museum of Anthropology, the University of British Columbia.
The photograph of a brooch by Bill Reid, p. 108, is reproduced courtesy of the Museum of Anthropology, the University of British Columbia.

Contents

FACING PAGE:
Framed by the lush foliage of a temperate rain forest, a bold and beautiful Steller's jay holds centre stage. Steller's jays are the blue jays of westernmost North America.
TOM & PAT LEESON

OVERLEAF: *A pair of European carrion crows delivers lunch to its unkempt brood.*
BENGT LUNDBERG, NATURFOTOGRAFERNA/N

Acknowledgements

I am one of those strange people who talk back to birds. In particular, I squawk at jays, croak at ravens and bark at magpies. I also caw at crows. This is a perpetual source of embarrassment for my closest associates ("Mother, do you have to do that?"), but I can't help myself. It's an irresistible impulse, an irresistible pleasure. For when I call to them, these birds—the members of the crow family, or corvids—often answer. There I stand, a silly human cawing for all I'm worth, and the bird looks calmly down at me and caws in return. Hello, hello.

What do you see when you look at me, Crow? What is going on behind that bright, knowing eye, Raven? Are you thinking about me thinking about you? Are you, in your own way, enjoying this brief moment of mutual recognition? I am grateful for all the fun I've had watching these spirited birds and teasing myself with questions about how their minds might work.

I am also grateful for the enjoyment I have found in reviewing the recent literature on corvids and on animal cognition. As a rule, the reading of technical publications is a surefire cure for sleepless nights. But the reports on which this book is based—as listed in the notes and bibliography at the end of the book—are energetic and compelling, notable for both their scientific rigour and their intellectual audacity. From Konrad Lorenz's pioneering studies of jackdaws

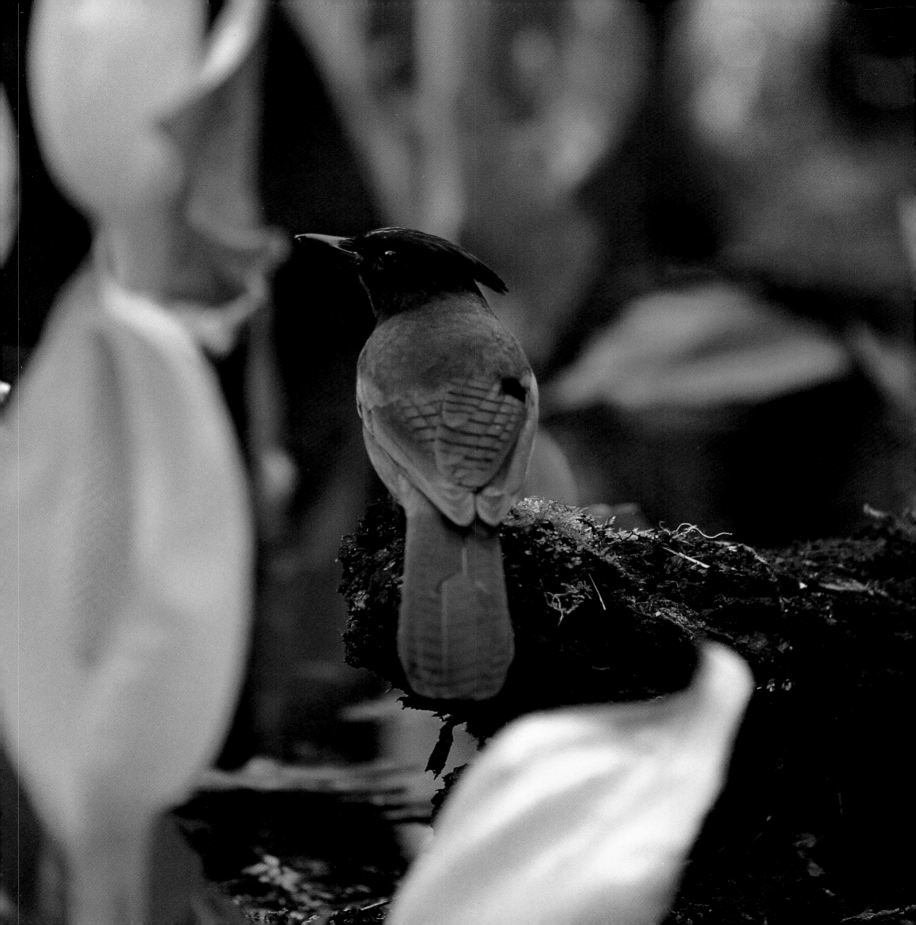

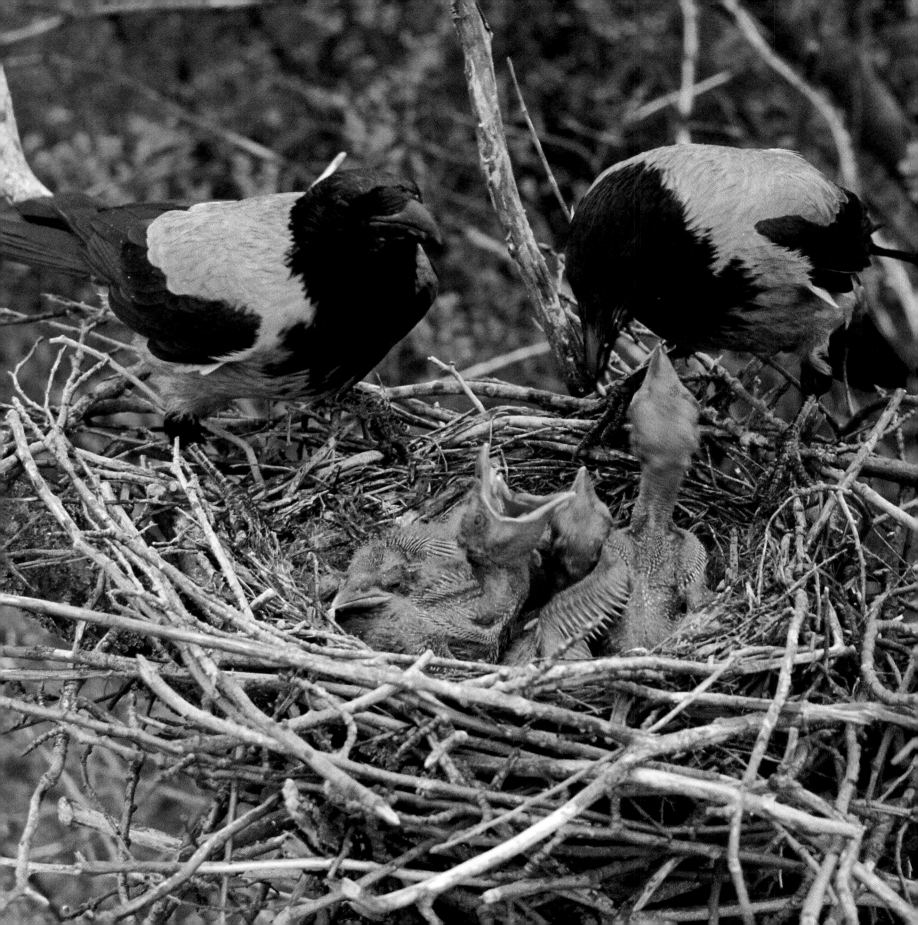

early in the century to Donald Griffin's up-to-the minute evocations of animal mentality, these writings invite us to look at the living world with a renewed sense of wonder.

I am honoured to acknowledge my personal debt to several researchers who have made notable additions to this literature. Irene M. Pepperberg of the University of Arizona reviewed portions of my text and made valuable comments. Alan C. Kamil of the University of Nebraska and Russell P. Balda of Northern Arizona University provided copies of their recent research papers, some of them before publication. Dr. Balda and Bernd Heinrich of the University of Vermont both found time to answer my questions by telephone. And John Marzluff, formerly with Northern Arizona University and now with Greenfalk Consultants, read the entire manuscript and offered a number of helpful suggestions.

It is also a pleasure to recognize the contributions of publisher Rob Sanders, editors Shelley Tanaka and Nancy Flight, and designer Tom Brown, all of whom brought their considerable talents to this project. Finally, thanks are due to Keith Bell and Diana Savage for their good-natured participation in this and so many other feather-brained endeavours.

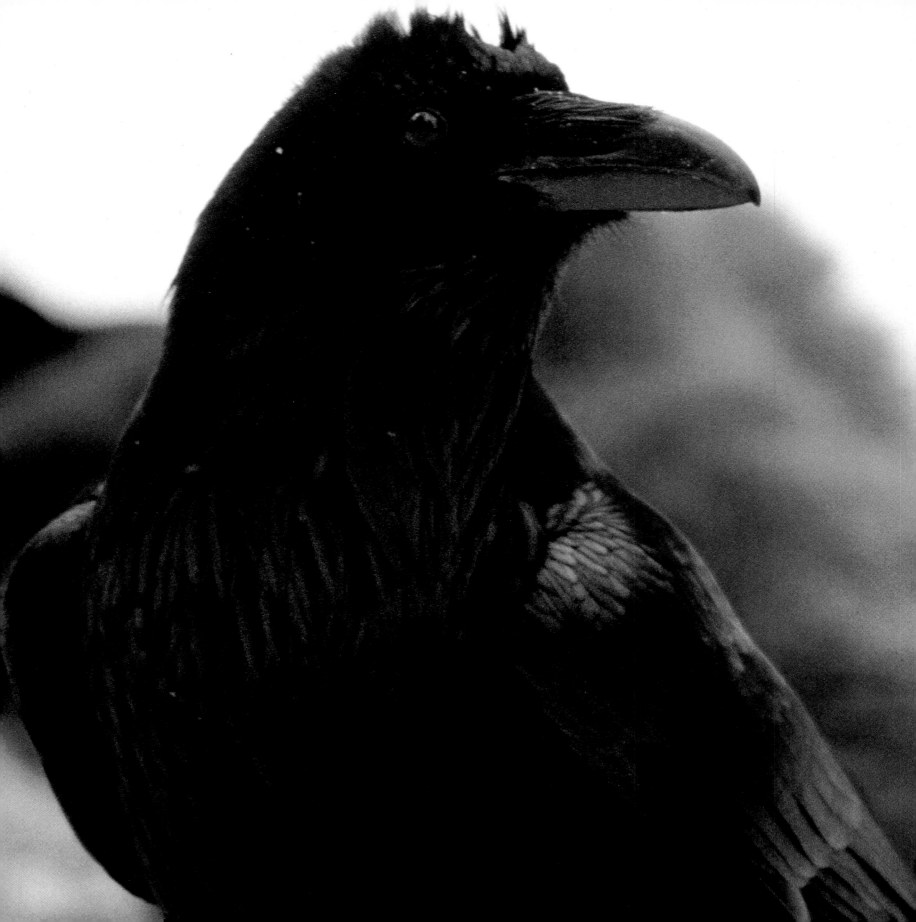

If men had

wings and bore black feathers,

few of them would be

clever enough to be crows.

—REV. HENRY WARD BEECHER, MID-1800S

Brainy Birds

It was just an ordinary crow, its shiny black feathers sleek against the pale spring morning. It leaned over the edge of the building on which it was perched, looked down at me and barked three times like a dog. Then it trilled once like a starling.

Pardon me? I stopped in my tracks and stared.

The crow cocked its head, fixed me with one bright eye and called again. "Ruff, ruff, ruff," it said. "Trreech." It was just an ordinary crow.

In the late 1960s, another ordinary crow lived at the Allee Laboratory of Animal Behavior at the University of Chicago, where it was observed by a scientist named Benjamin Beck. As Beck tells us in his book *Animal Tool Behavior*, this bird was fed partly on dried mash, which its keepers were supposed to moisten. But sometimes (being merely human) they forgot.

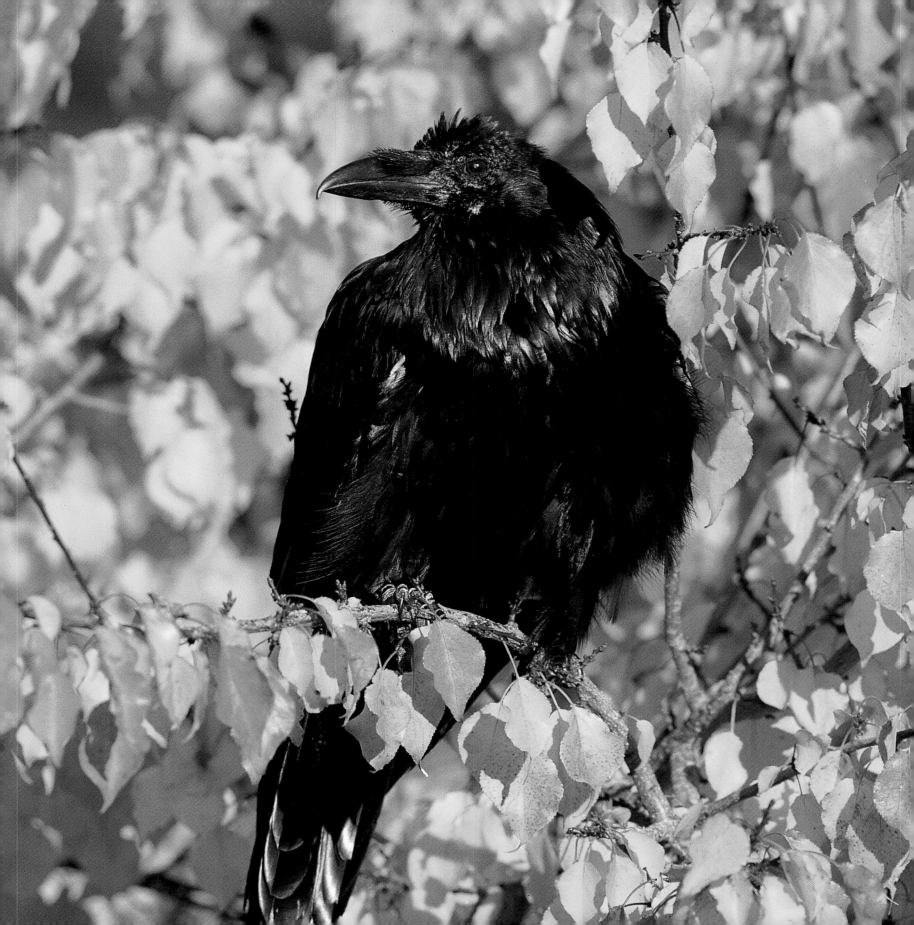

The crow, undaunted, would then pick up a small plastic cup that had been provided as a toy, dip it into a water trough, carry the filled cup across the room to the food and empty the water onto the mash. "If the water was spilled accidently," Beck writes, "the crow would return to the trough for a refill rather than proceed to the food pan with an empty cup."

The bird was not taught to do this. "The behavior appeared spontaneously," Beck reports.

From the point of view of science, a raven is nothing more or less than an oversized crow. Jacob was an ordinary raven that lived in the laboratory of a German ethologist named Otto Koehler. For reasons of his own, Koehler believed that birds might have an innate sense of number. To test this conjecture, he designed a series of experiments in which Jacob the Raven was presented with a group of two, three, four, five or six small objects. Beside this "key" was placed a set of five small boxes, each identified with two, three, four, five or six black marks. The objects in the key and the marks on the boxes differed in size, shape and positioning and were changed from trial to trial.

Jacob's task was to match the number of objects with the number of marks on one of the lids, open the correct box and obtain a food reward. In trial after trial, this is exactly what he did. Without the aid of language, Jacob the Raven could count to six.

Birds of a Feather Crows and ravens are members of a remarkable group of birds known by the unremarkable name of the crow family. Accorded the dignity of scientific Latin, they become the Corvidae, or corvids. There are 103 species of these crowlike birds in the world, though only forty of them qualify as "true crows." Classified as members of the genus *Corvus*, this grouping includes the whole

Typical Members of the Crow Family

American Crow, *Corvus brachyrhynchos*
A large crow (almost twice the size of an American robin) with a fan-shaped tail and nasal *caw* call. Occupies a wide variety of habitats. Northerly breeders may migrate. Similar northwestern crow occupies west coast.
Eggs: 4–7, greenish or bluish blotched with brown.

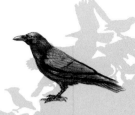

Carrion Crow, *Corvus corone*
The most widespread crow in Europe. Similar to the rook but with a stout bill and fully feathered face. Some races, the hooded crows, have white "cloaks." Northernmost breeders may migrate. Eggs: 2–7, greenish blue marked with olive-brown.

Rook, *Corvus frugilegus*
A large crow (two-thirds the size of a raven) with a long pointed beak, bare whitish face and "baggy" leg feathers. Prefers fields with trees; nests colonially. Northerly breeders migrate. Eggs: 3–5, greyish green blotched with brown.

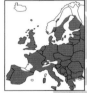

Jackdaw, *Corvus monedula*
The smallest European crow (just larger than a blackbird) with a short, pointed bill and grey "shoulders." Nests colonially in holes in trees, buildings and cliffs. Northerly breeders migrate. Eggs: 3–7, greenish blue spotted with grey.

Common Raven, *Corvus corax*
A huge, stately crow (as big as a large hawk) with a heavy bill, diamond-shaped tail and resonant voice. Most common in mountains and rugged country.
Eggs: 4–7, greenish blotched with brown.

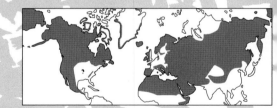

Nutcracker, *Nucifraga nucifraga*
A striking brown bird with white spots (somewhat like a winter starling but half as large). Found year-round in coniferous forests in the mountains; in the winter also in deciduous forests. Eggs: 2–4, bluish green speckled with brown.

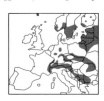

Clark's Nutcracker, *Nucifraga columbiana*
A grey bird (just larger than an American robin) with black and white wings and tail. Occupies coniferous forests at the timberline in the mountains.
Eggs: 2–4, greenish with brown spots.

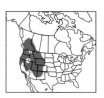

The maps show approximate year-round distributions for all species except carrion crows, rooks and jackdaws, which are partially migratory. Breeding ranges for these species are indicated.
The maps are based on information in *The Atlas of European Birds* by K.H. Voous, 1960; *Birds of Britain and Europe* by Roger Tory Peterson, 1993; and the National Geographic Society *Field Guide to the Birds of North America*, 1983.

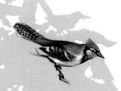

Blue Jay, *Cyanocitta cristata*

A spectacular crested jay with black bars and white patches on the wings and tail. Piercing *jay, jay* call is heard in gardens, parks, woodlands. Northerly breeders migrate. Similar Steller's jay occurs in the West. Eggs: 4–6, olive marked with brown.

Mexican Jay, *Aphelocoma ultramarina*

A greyish blue jay with a light breast. Found in oak canyons of the southwestern United States and south into Mexico. Often nests in small colonies.
Eggs: 3–7, green speckled with brown.

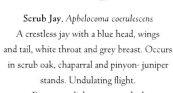

Scrub Jay, *Aphelocoma coerulescens*

A crestless jay with a blue head, wings and tail, white throat and grey breast. Occurs in scrub oak, chaparral and pinyon-juniper stands. Undulating flight.
Eggs: 2–5, light green marked with brown and lilac.

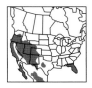

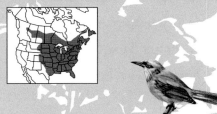

Pinyon Jay, *Gymnorhinus cyanocephala*

An all-blue jay with a long, spiky beak. Lives in large flocks, often several hundred strong, and nests in colonies. Common in the pinyon-juniper forests of the high country. Eggs: 3–6, bluish speckled with brown.

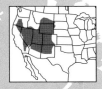

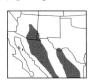

Eurasian Jay, *Garrulus glandarius*

A noisy, colourful bird with a streaked forehead, black moustache and brilliant wing patches. About the size of a large crow. Favours woodlands.
Eggs: 3–7, light green with speckles of brown.

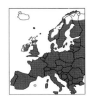

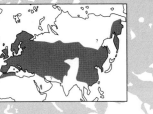

Black-Billed Magpie, *Pica pica*

Easily recognized by its black and white markings and long, iridescent tail. Prefers farmland and open woods. Builds conspicuous domed nests.
Eggs: 6–9, green-grey marked with brown.

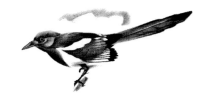

Siberian Jay, *Perisoreus infaustus*

A fluffy grey-brown bird with orange-red on the wings and tail. Mostly in coniferous forests. Found around villages and logging camps in the winter. Eggs: 3–5, greyish green freckled with brown.

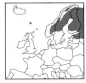

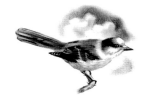

Gray Jay, *Perisoreus canadensis*

A fluffy grey bird with a small bill. Common in coniferous forests. Frequent visitors to campsites. Also known as Canada jay and whisky-jack.
Eggs: 4–6, mottled greenish brown.

familiar tribe of black banditti: crows, jackdaws, rooks and ravens. Despite considerable differences in size—the burly raven weighs three times as much as an average crow—there is a sense in which "if you've seen one, you've seen them all." Their wild black wings and metallic shouts make them instantly recognizable.

The other sixty-three species in the family are all stocky birds with strong bills and harsh voices. (Although technically corvids are songbirds, none would take a prize for tunefulness.) A few—such as the choughs of western Europe—are crowlike in colour and form. But others, including the green jay of the American tropics and the green magpie of Southeast Asia, are as brilliant as parrots, with plumage in eye-popping shades of emerald, yellow and red. Many well-known members of the family are only slightly less glamorous: the bright-winged Eurasian jays, the elegantly patterned nutcrackers and the exotic, ever-squawking magpies. The family also includes such familiar birds as the soft-feathered gray jays of the northern forest and more than two dozen shimmering blue-backed jays that flash through the woodlands of the Americas.

Taken as a whole, the corvids are the top of the line in avian evolution, among the most recent and successful of modern birds. From some unknown pinpoint beginning, they have diversified and expanded to occupy most of the globe. (They are present on every continent except Antarctica and in every country except New Zealand.) Whether you go to the Sahara or the Amazon rain forest, you will likely be met by some kind of crow or crow-cousin, which will eye you boldly and shout if you come too close. I have traded calls with a raven basking in the winter sun at Tuktoyaktuk, on the Canadian Arctic coast; the temperature was 42 below. Five days' drive to the south and fifty degrees warmer, I have watched a crow carrying twigs into a spruce tree that overlooks frantic traffic at a city intersection. Regardless of what nature or human nature has thrown at them, corvids have consistently proven themselves to be up to the challenge.

Corvophobia

In many parts of the world, human persecution has been a consistent and considerable threat to the well-being of corvids, especially ravens and crows. To some people, these birds are as unappealing as cockroaches and as undeserving of sympathy. "Grim, ungainly, ghastly, gaunt, and ominous" (in the words of Edgar Allan Poe), they are—in some

people's eyes— creatures that make your skin creep. Black as shadows, they rustle unseen in the treetops. Eerie as night, they swoop overhead with a hiss. Dark as death, they land in hoarse-voiced, squabbling flocks to feed on rotting carcasses.

Worse yet, crows, ravens and other corvids often seem to plot against human interests. Crows steal crops that we have planted to feed our families. Ravens rip into the garbage and spread debris around the streets. Together with magpies and jays, they steal eggs and nestlings from our favourite songbirds. They harass livestock.

On the basis of these observations, some people think of corvids as vermin that ought to be eradicated. In 1989, members of the British House of Lords rose in outrage against the suggestion that they be protected by law. "Capital punishment for the thieving and murderous magpie," one of them trumpeted. A few years earlier, an American hunting magazine urged its readers to take up crow shooting as a cure for cabin fever. In many rural areas, taking pot shots at magpies and crows is still seen as a respectable pastime—indeed a public service.

From an economic viewpoint, this harassment is frequently unjustified. Although the birds' depredations may be real, our accounting of them is almost always exaggerated and one-sided. Not only do we routinely overestimate our losses, we seldom give corvids credit for the ways in which they are beneficial to us. (According to one study, only 1 per cent of the food eaten by crows during the seeding season in New York consisted of corn. In another, a single family of crows was found to devour about forty thousand grubs, caterpillars, army worms and other agricultural pests during the nesting period.) Nor do we customarily acknowledge the role of predators, including corvids, in maintaining the health and "fitness" of their prey, such as songbirds.

THE THREE CROWS

There were three crows sat
 on a tree.
They're as black as crows
 can be.
One of them said to the
 mate:
What shall we do for grub
 to eat?

There's an old dead horse
 in yonder's lane,
Whose body has been lately
 slain.
We'll fly upon his old breast
 bone,
And pluck his eyes out one
 by one.

—A traditional ballad

9

The companionable gray jay is familiar to anyone who has visited the spruce forests of northern North America. Its many colourful nicknames—Canada jay, whisky-jack, meat-bird, moose-bird and camp robber, among others—tell much about the species' diet, habitat and dealings with humans.

ALBERT KUHNIGK,
VALAN PHOTOS

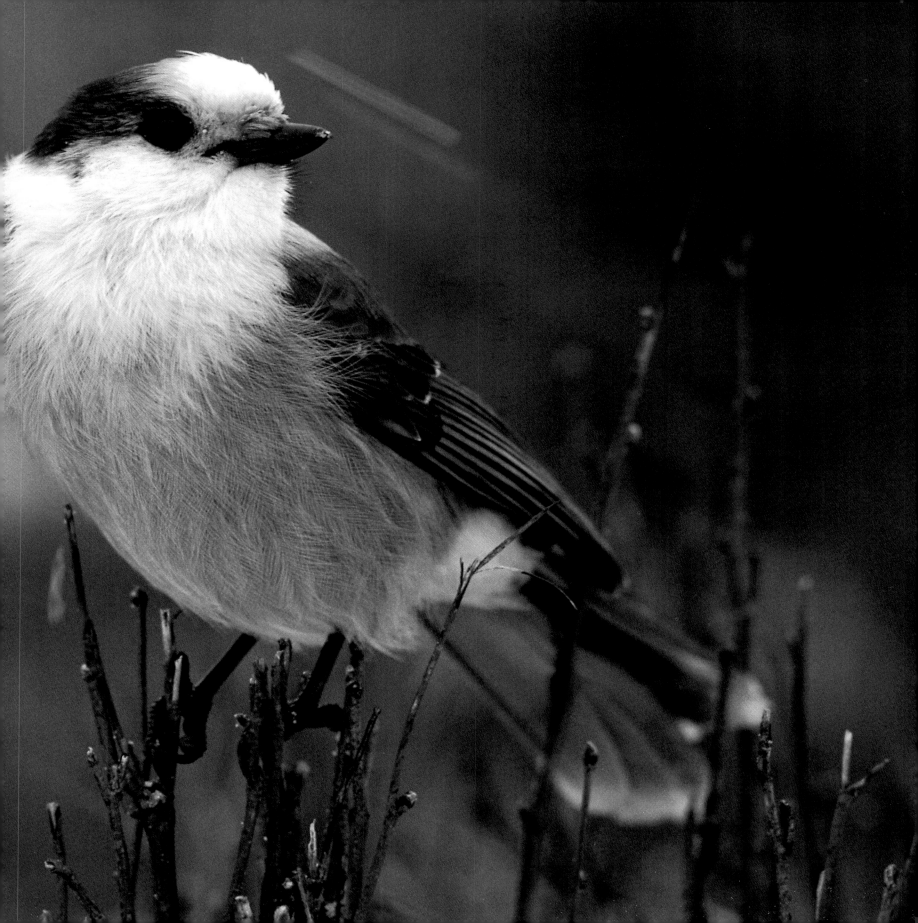

Fortunately—despite the slaughter of thousands and tens of thousands of individual birds—crows and other corvids are not known to have declined in overall numbers in recent years. In fact, populations of several species seem to be increasing in many localities as the birds expand into habitats that have been created for them by farming, forestry, city building and other human activities.

The Secret of Their Success?

To a greater or lesser extent, all species of corvids are adaptable, able to respond to changing conditions by changing the way they act. For example, a bird that shares its feeding grounds with its neighbours when food is plentiful may turn into a vociferous defender of private land rights when food is in short supply. In part, this admirable flexibility is the result of a generous genetic inheritance, which equips the birds with a variety of possible responses to varying circumstances. But flexibility can also be a mark of intelligence—the ability, as *Webster's* has it, "to perceive relationships and use one's knowledge to solve problems and respond appropriately to novel situations."

As a group, corvids are commonly said to be uncommonly smart. Everybody, it seems, has stories about Blackie, the childhood pet crow, who teased and tormented the family dog and finally managed to steal food right out from under poor old Fido's nose. Crows are cunning, people say, and clever enough to enjoy a joke at someone else's expense. Certainly, this is the view expressed by an ancient cycle of myths that stars Crow or, more often, his big brother, Raven. In these stories, which were once told all across Siberia and northern North America, Raven is a wise guy and practical joker who, as creator of the world, imparts his lustful, greedy, irreverent spirit to everything he touches. (In a moment of boredom, he impulsively adds genitals to his

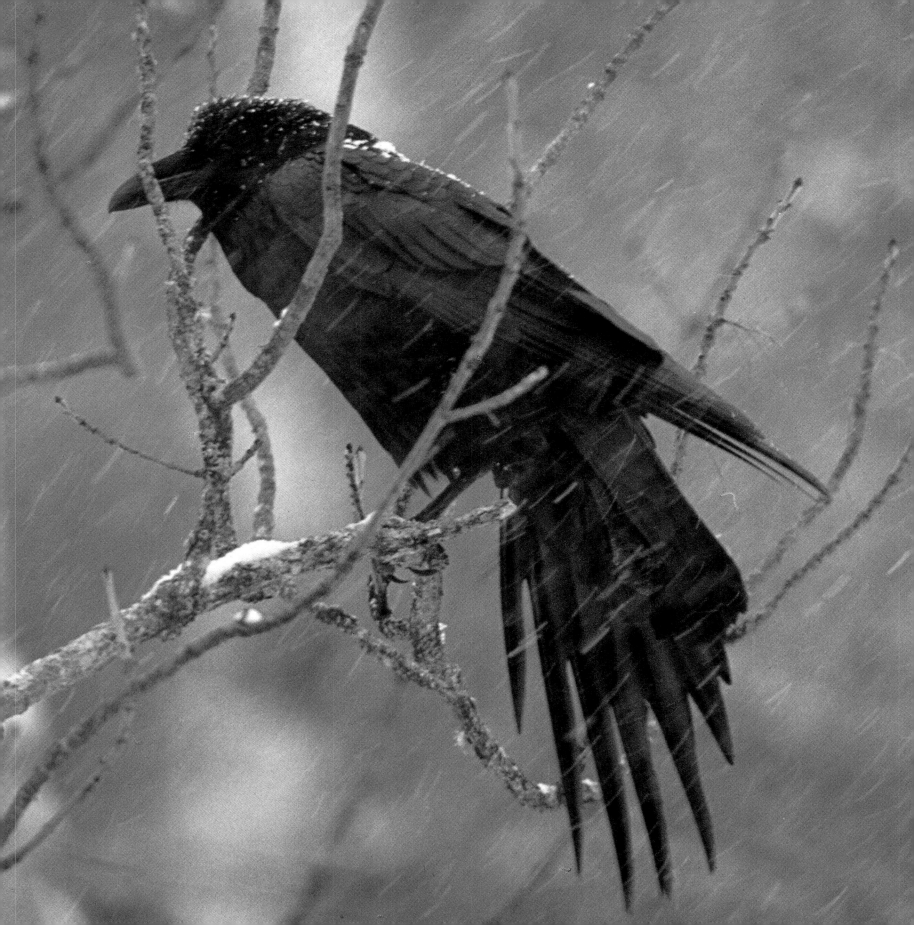

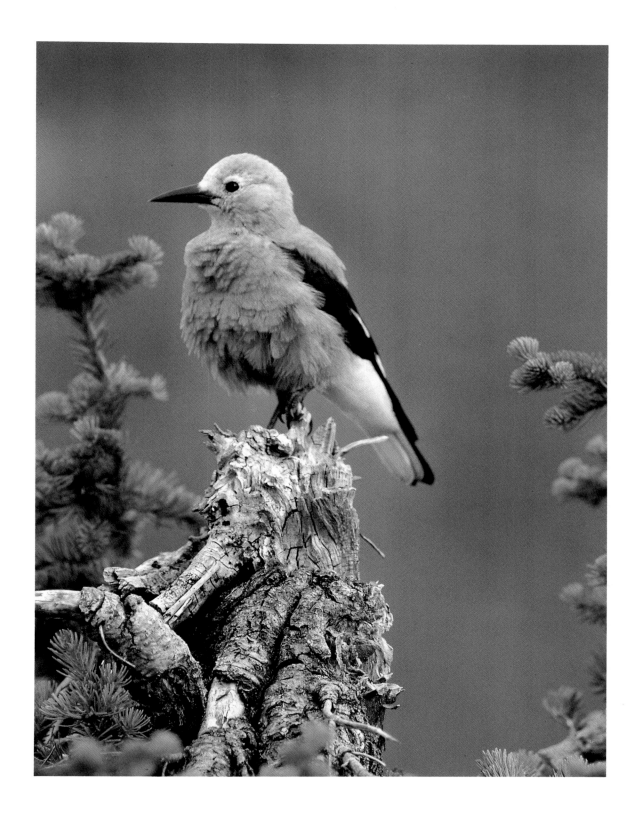

MAGPIE COUNTING
RHYME

One for sorrow,
Two for mirth,
Three for a wedding,
Four for a birth,
Five for rich,
Six for poor,
Seven for a witch—
I can tell you no more.

—English counting rhyme

FACING PAGE:
*Prepare the marriage
feast. According to a
widespread folk belief,
the future can be
divined by noting the
number of magpies that
sweep past.*
HANNU HAUTALA

creatures, thereby inventing what the legends call "Raven's greatest game.")

In other traditions, corvids are often credited with a less earthy but nonetheless potent wit and wisdom. In Norse mythology, for example, the god Odin had two ravens, named Thought and Memory, that flew around the world all day and came back at night to bring him up to date on what was happening. In Ireland, the phrase "raven's knowledge" speaks of an oracular ability to see and know everything. Even time is no barrier to the ravens' gifts of perception, since they, along with crows and magpies, can see beyond the present. In the classical period, learned members of the Roman College of Augurs confidently foretold events that had been revealed to them by the croaking of corvids.

Total omniscience is a lot to expect, even from a crow. So, fortunately, modern science is more tempered in its judgements of the birds' mental prowess. Nonetheless, they are held in high regard by many scientists. In *The Audubon Society Encyclopedia of North American Birds*, for example, ornithologist John K. Terres suggests that corvids have probably achieved "the highest degree of intelligence" to be found in any birds. And if the family as a whole hasn't earned this honour, then perhaps one or another of its members deserves the credit. Naturalist Tony Angell claims first place for the American crow, on the grounds that it has proven "superior in intelligence to all other avian species tested" in the laboratory. Zoologist Bernd Heinrich gives the crown to the common raven, which he notes is often "assumed to be the brains of the bird world." This opinion is seconded by (among others) the noted animal behaviourist Konrad Lorenz, who credits the raven with the "highest mental development."

But in a 1991 paper on animal cognition, Irene M. Pepperberg of the

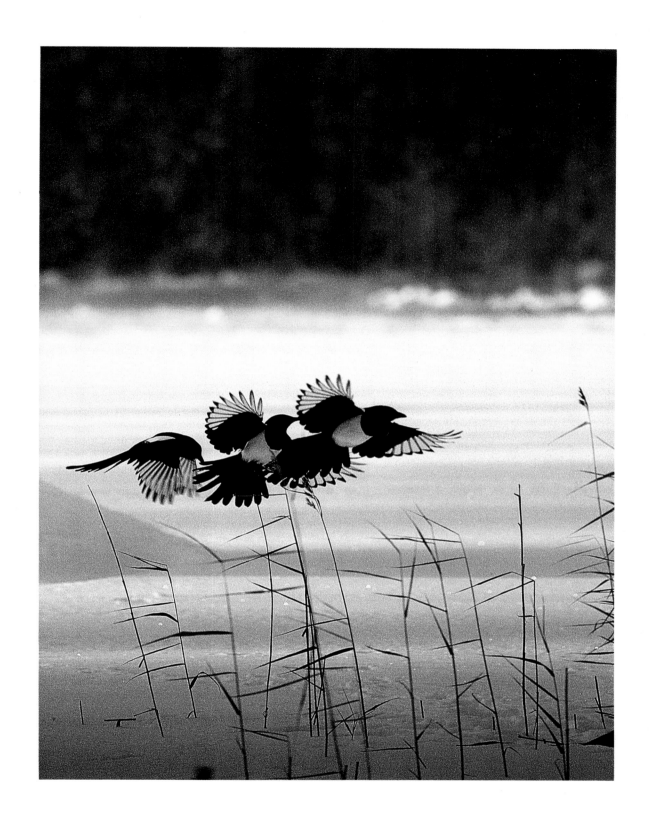

University of Arizona spreads the glory around to include not only crows and ravens but also their close relatives, jays and jackdaws. From a careful review of the scientific literature, she concludes that these birds are indeed superbly intelligent, although they may have to vie for first place with mynas and parrots. (Alex, an African gray parrot trained in Pepperberg's laboratory, is able to identify more than one hundred items by name and to distinguish similarities and differences by category. For example, if he is shown three triangles of different colours and asked, "What's the same?" or "What's different?" he gives the correct answer— "Shape," "Colour"—in four trials out of five.)

Judging from the studies that have been published to date, Pepperberg believes that corvids and a few other species are likely "capable of acquiring [the] complex vocal and nonvocal behaviors that many scientists believe are co- or prerequisites for referential communication." And overall, she affirms, they may share the "cognitive capacities" of many primates. In one experiment, for instance, a raven was given the task of identifying the odd-shaped object in an array of six otherwise identical items. Its performance put it on a par with gorillas and chimps, our own species' closest relatives.

Taboos and Prejudices
If Pepperberg is correct, then the pair of crows that are cawing like mad in a tree across the street are as smart as (or smarter than) a pair of monkeys. As we have seen, this assertion is in harmony with the common sense of world folk belief. But, as Pepperberg herself would be among the first to admit, the *scientific* evidence for the birds' superior powers is inconclusive. To date, all the experimental results point in the same direction—in various trials, corvids have scored better than chickens, quail, pigeons, rabbits, cats, elephants, gibbons and rhesus monkeys. But the scientific community has been slow to pick up on these tantalizing hints. As a result, there have been few tests with few birds in few laboratories.

The ascription of meaningful intelligence to nonhuman creatures causes an immediate *crise de nerfs* among orthodox scientists. To them, the subject carries a mousy smell of fakery and hoax that lingers from the errors of the past century. Then, well-intentioned experts had found themselves deceived by a horse named Clever Hans, whose apparent ability to solve arithmetic

problems turned out to be based on a real ability to read subtle cues from the people around him. As long as his audience continued to nod and smile, Hans continued to tap out the answers. No one likes to be embarrassed, "experts" perhaps least of all, and scientists soon began to avoid the whole question of cognition in animals. Their queasiness was eventually codified by "behaviourist" psychology, which taught that mental functions, such as memories, insights and thoughts, cannot be directly observed and hence are of no interest or value to serious science.

Under this ban, anyone who ascribed intelligent awareness to animals or birds was tried and convicted in the first instance. The offence was the dreaded thought-crime of "anthropomorphism." Strictly speaking, anthropomorphism refers to the too-easy ascription of human emotions and mental processes to nonhuman animals. ("If I were a crow in a certain situation, this is what I—as a human—would be thinking and feeling. Therefore, that must be what the crow is experiencing too.") But the term is often used, more loosely, to condemn any suggestion that sophisticated awareness may occur outside our own species. As such, not only does it serve to police the boundaries of orthodox science, it also protects our sense that human beings are uniquely superior. Having defined ourselves as something other than "dumb animals," we have a lot invested in keeping the animals dumb.

Robo-Birds
Prevented by its own prejudices and taboos from asking the most interesting questions, science was left with the most boring of answers. In the opinion of many researchers, birds were little more than feathered automatons, every aspect of their behaviour tightly controlled by their genetic code. Exposed to appropriate stimuli—of day length, hormones or social arousal—these living robots responded by running through their repertoire of preordained behaviours—courting mates, building nests, feeding their young. See a twig; weave it into a nest cup. See a gaping mouth; stuff food into it. Like computers programmed to respond to the push of a key, the birds were programmed to react when something in their environment pushed their psychic buttons.

It has to be admitted that this description sometimes seems apt. Birds, even corvids, often act in ways that look remarkably stupid. In *King Solomon's Ring*, for example, Konrad Lorenz

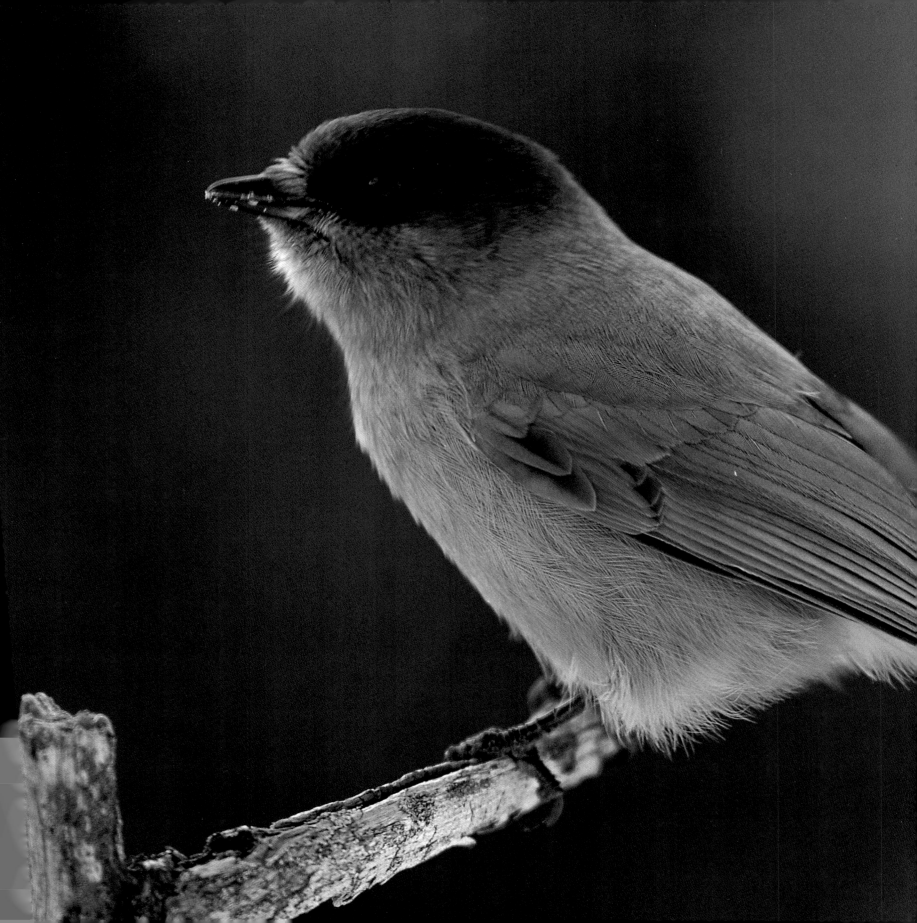

The fiery orange
under-feathers of
the Siberian jay add
a warm touch of
colour to coniferous
forests across northern
Europe and Asia.
The Siberian jay and
the gray jay are
companion species,
occupying similar
habitats in the Old
and New Worlds,
respectively.

HANNU HAUTALA

writes about his pet jackdaw Tschock, who was "as tame as any dog"—until the day Lorenz picked up a small black jackdaw chick. This young bird was one of a group of newcomers to Lorenz's captive colony, and as Lorenz tells the story, Tschock hated them all "most cordially." "I was forced to protect them from her continually," he recalls. "She would have destroyed them, at one fell swoop, if she had been left alone with them for a few minutes." Yet the instant the chick was in Lorenz's grasp, Tschock descended on him like a missile. "Astonished, I stared at a round, bleeding, deeply pecked wound in the back of my hand!"

A few weeks later, Lorenz committed a similar offence in the presence of his whole flock and immediately found himself "surrounded by a dense cloud of raging, rattling jackdaws, which hailed agonizing pecks upon my offending hand." Only this time the black object he held was not a bird; it was a pair of black bathing trunks.

As Lorenz eventually determined, the jackdaws were in the grip of a reflex that was automatically triggered by the sight of a limp black object—any limp black object—fluttering in someone's grasp. Thus, his tame jackdaws sat quietly when he handled their downy nestlings, because the chicks were not yet black. But if he picked up a fledgling or tried to rescue an adult from a trap or even held the strips of black paper from a film pack, he could confidently expect to be attacked. Under natural conditions, where downy chicks were safely hidden in their nest holes and fluttering black objects were always jackdaws in need of assistance, the birds' innate behaviours might look entirely reasonable. But in fact, their actions were rigidly determined by their genetic code and were no more susceptible to reason than their feathers or their bones.

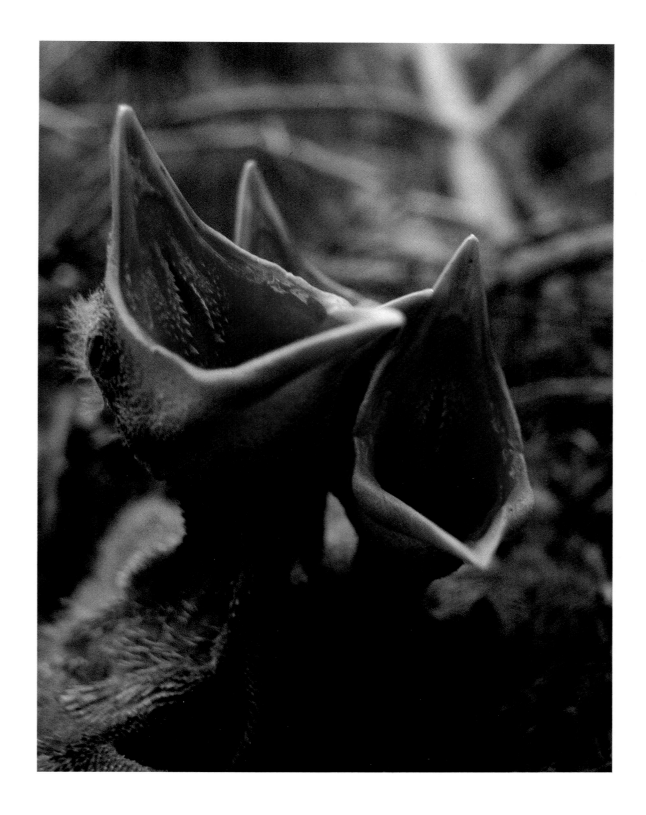

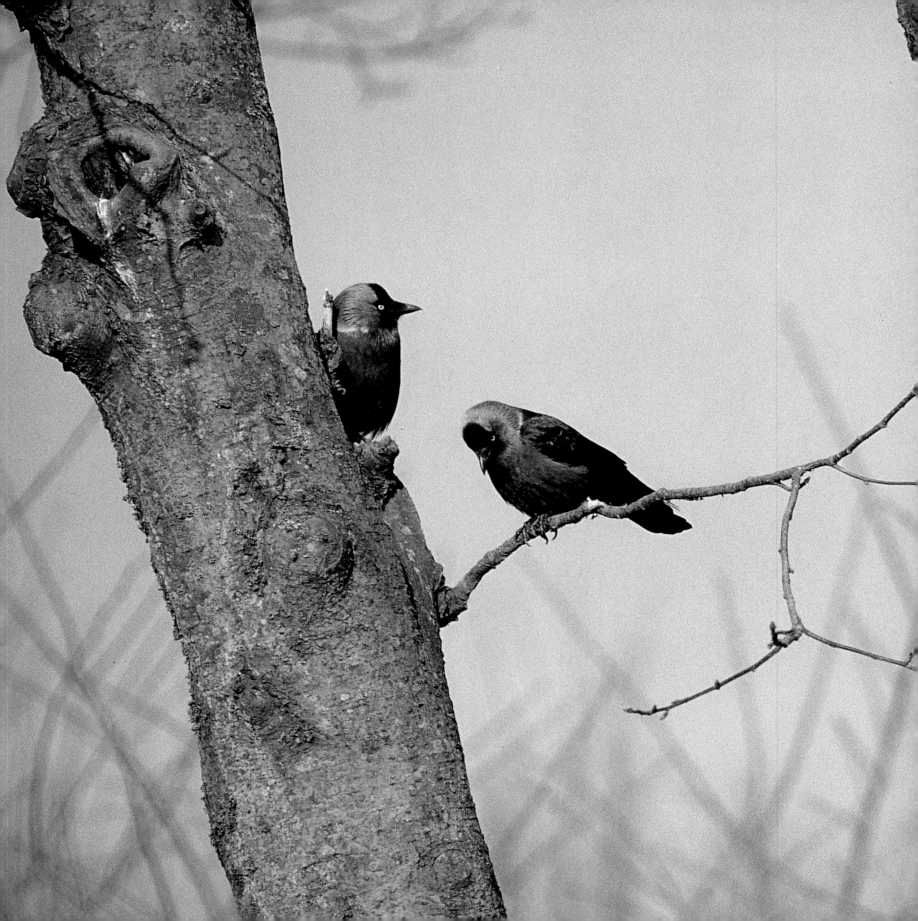

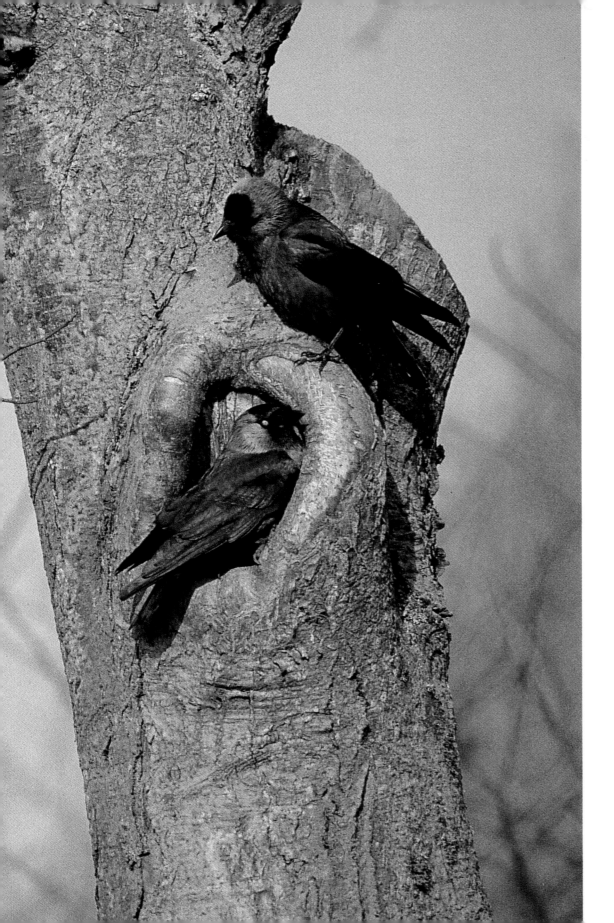

Two pairs of jackdaws contest the occupancy of a single nest hole. Small and quick-winged, jackdaws can be distinguished from other European crows by their surprising silvery eyes.

JAN JOHANNESSON,
NATURFOTOGRAFERNA/N

Brain Power

Thus, even an allegedly smart bird like a jackdaw could be likened to an intricate machine that was controlled by inflexible patterns laid out in its circuitry. The only role for the brain of such a creature was to facilitate these routine connections—input, output; stimulus, response—as the bird moved numbly through its daily actions. And perhaps this low level of functioning was the best that one could expect, since the brains of birds were judged to be structurally primitive. In particular, the cerebral cortex (the organ of higher thought in humans and other mammals) looked distressingly small and poorly developed. Small wonder that even the brightest of birds appeared to be such dim bulbs.

But Lorenz was not satisfied with this description. Although it was clear that his jackdaws had inherited certain reflexive behaviours, he knew that these same behaviours could be modified through the birds' personal experience. Thus, if a person raised the limp-black-object alarm several times in a row, Lorenz's jackdaws quickly came to recognize and attack him on sight, even if there was now no "dying jackdaw" to elicit a response. The innate stimulus-response chain had been altered by learning, and this acquired knowledge was quickly communicated to all the other jackdaws in the area. "Almost before you know it, you are notorious amongst the jackdaws in the whole district as a beast of prey which must at all costs be combatted."

Even more remarkable, in Lorenz's view, was the discovery that his young jackdaws had no inborn reaction to predators. They had to learn from their parents' example what to trust and what to fear. If the elder jackdaws took food from Lorenz's hand, their fledglings would hop into his palm with them. But if the adults responded to someone or something with alarm, the young birds quickly developed an identical phobia. Thus, Lorenz concluded, "an animal which does not

FACING PAGE:
Once considered a species in its own right, the aptly named hooded crow has been demoted to the status of a subspecies and placed under the ill-favoured label of "carrion crow." These striking black and white markings are worn by the carrion crows of northern Scotland, Scandinavia and central Eurasia. At both the western and eastern extremes of the species' range (in western Europe and eastern Asia), the birds are pure black.
HANNU HAUTALA

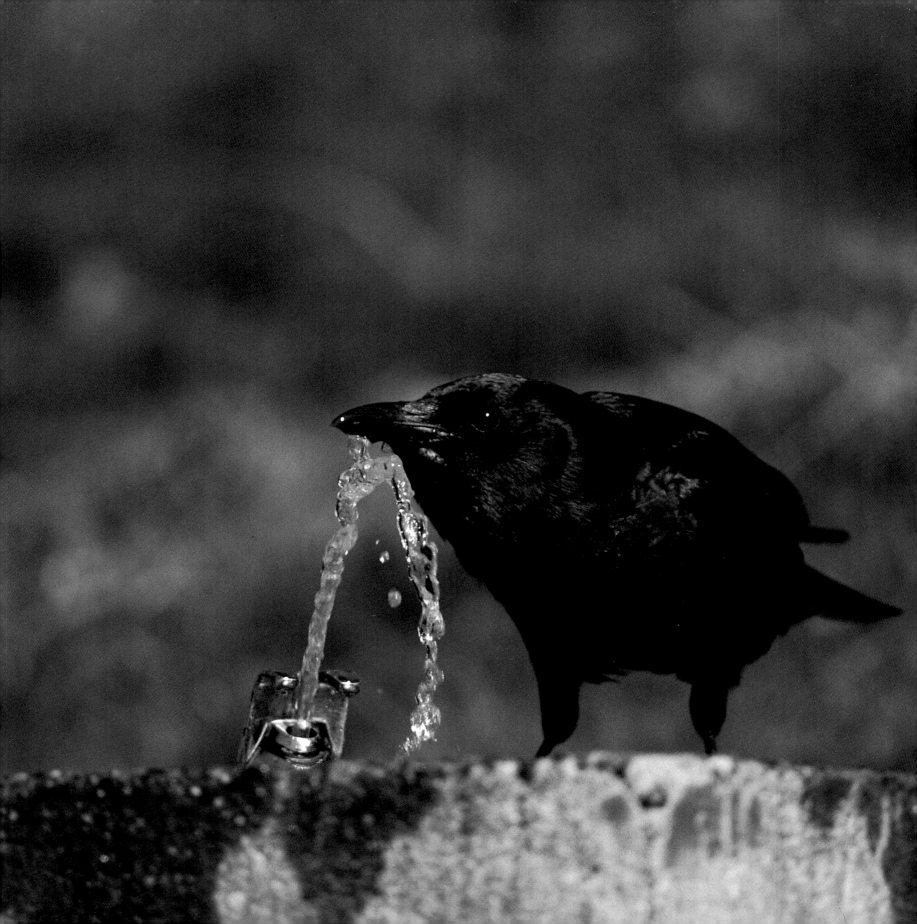

know its enemy by innate instinct, is informed by older and more experienced fellow-members of its species who or what is to be feared as hostile. This is true tradition, the handing-down of personally acquired knowledge from one generation to another."

In Lorenz's interpretation, jackdaw behaviour was indeed programmed—but only in part. There were "gaps" in the birds' genetically encoded responses, and these gaps were filled by on-the-spot learning. "The inherited and acquired elements of a young bird's behavior are pieced together [like the stones of a mosaic] to produce a perfect pattern." Corvids, he thought, were probably better able than other birds to fill in the blanks, given their "undoubtedly great learning abilities and their extremely characteristic tendency to try out novel patterns of activity."

But can a mere bird brain really cope with this intellectual challenge? How can birds learn and remember without an elaborate cerebral cortex? By the 1960s, neurologist Stanley Cobb had the answer. The avian brain, he discovered, is built on its own unique plan. Instead of relying on the cortex, birds have developed another part of the forebrain, the hyperstriatum (which mammals lack), as their chief organ of intelligence. The larger the hyperstriatum, the better birds fare on intelligence tests. Crows, ravens and magpies are all at the high end of both scales. And, as other investigators have since determined, corvids are also tops among birds for overall brain size. (Their brain-to-body ratio equals that of dolphins and nearly matches our own.) What's more, their large brains are packed tight with exceptionally large numbers of brain cells.

But exactly what goes on inside those well-stocked heads? Are corvids conscious? If so, are they aware of their own internal states, such as fear or loneliness? Do they have ideas or see images in their

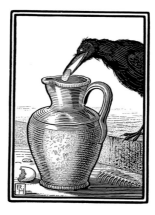

THE CROW AND THE PITCHER

A thirsty Crow found a Pitcher with some water in it, but so little was there that, try as she might, she could not reach it with her beak, and it seemed as though she would die of thirst within sight of the remedy. At last she hit upon a clever plan. She began dropping pebbles into the Pitcher, and with each pebble the water rose a little higher until at last it reached the brim, and the knowing bird was enabled to quench her thirst.

Necessity is the mother of invention.

—Aesop

FACING PAGE: *A crow takes advantage of the conveniences in Stanley Park, Vancouver, British Columbia.*

mind's eye? Can they analyze situations and solve problems? Does a hungry raven actively remember the garbage at the dump and purposefully set out to get some? Does a magpie consciously assess potential nest sites and then choose this tree instead of that one? Does a jackdaw intentionally teach its young? Does a crow know what it is "saying" when it barks like a dog? Or do the birds just do what they do, and life goes merrily on?

Isolated as we are inside our own minds, we cannot easily answer these questions. But just as we can sometimes read a person's thoughts by watching what she does—"Diana just took off her coat; I bet she was too hot"—so we can, *with appropriate humility and care,* study the mental processes of birds by watching and interpreting their actions. Obviously, we will not always be able to reach definitive conclusions about the meaning of what we have seen. The birds have all the answers, and they're not talking. But by examining the mute evidence of their daily activities, we can at least affirm one radical generalization. Crows, ravens, magpies and jays are not just feathered machines, rigidly programmed by their genetics. Instead, they are beings that, within the constraints of their molecular inheritance, make complex decisions and show every sign of enjoying a rich awareness. It is time to look again.

With that

wonderment which is the birth-act of philosophy, I suddenly start to query the familiar.—KONRAD LORENZ, 1952

Beginnings

A bird's nest is the ultimate in appropriate technology. Starting with the most unassuming of local materials—dry twigs, dead leaves, strips of bark—a bird fashions a snug cup that holds fast against spring winds and summer storms, providing shelter from the elements and protection from predators. Among songbirds, this delicate, durable structure is shaped almost entirely with the beak.

To make the performance even more impressive, every bird constructs the kind of nest that is "right" for its species. Crows, for example, generally choose a crotch in a sturdy tree (or occasionally a ledge on a cliff), on which they establish a rough platform of strong sticks. Once this has been accomplished, they bind the structure together with an inner layer of roots, mud and frayed bark, which form a deep bowl. Finally, the receptacle is cushioned

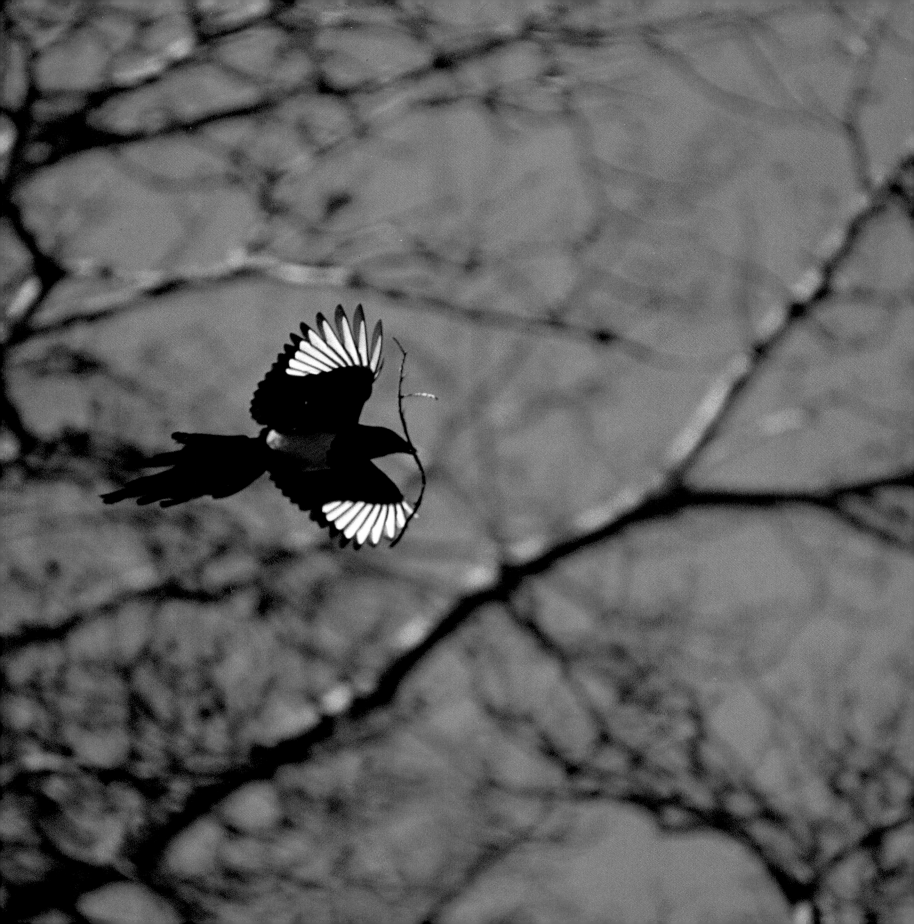

with a layer of soft, warm materials: grass, leaves, moss, feathers, fur or wool. This basic construction holds for most of the "true crows," including the American and carrion crows, the rook and the common raven.

But the jackdaw (another "true crow") has broken the ancestral mould. Although it usually builds a standard crow nest—a soft cup in a rough bowl on a rugged platform—it does not locate its domicile in the open air. Instead, a jackdaw seeks the shelter of a crevice or hole, whether in a tree, a cliffside, a ruined building, an abandoned nest or, notoriously, down someone's chimney. The reason for this adjustment is thought to be that jackdaws share their preferred habitat with carrion crows, which are larger, more aggressive and, when the opportunity arises, skilled thieves of eggs and nestlings. In the distant past (or so the theory goes), jackdaw ancestors still built open nests, and the dreaded opportunity arose all too frequently. But through a fortunate mutation, some individuals acquired a tendency to hide away in holes, with the result that more of their young survived to breed and pass on this characteristic. In time, cavity nesting became a defining feature of the whole species.

A similar story is told about the large, untidy domed nests built by black-billed magpies. A magpie nest is a major engineering feat— a structure composed of perhaps fifteen hundred sticks, cemented together with a layer of mud and, sometimes, cow dung. This container is then lined with fine roots and stems, supplemented with bark fibres, hair and grass. Overarching the whole structure, the birds construct a protective roof of twigs, often armed on the outermost surface with thorny branches. One or two openings in the sides let the magpies fly in and out of their fortress. But nest predators, including owls and large crows, find it difficult to breach these defences, and this is presumably

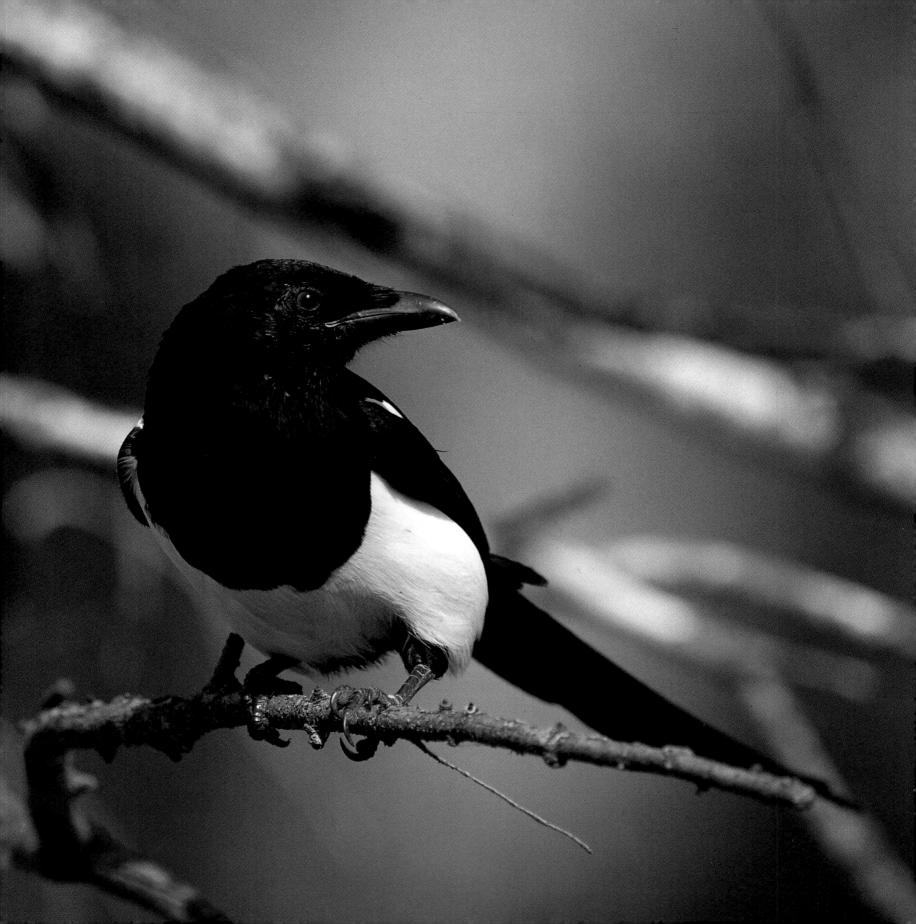

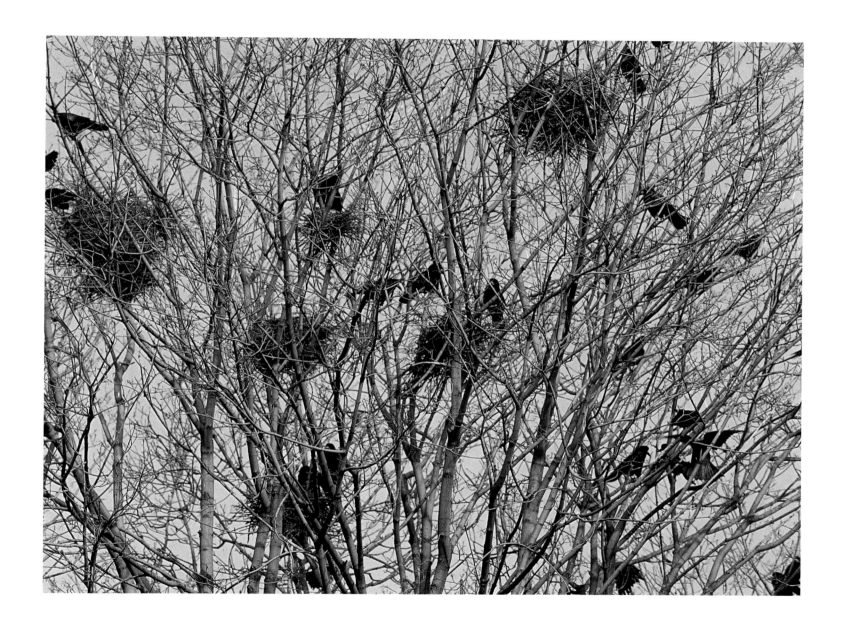

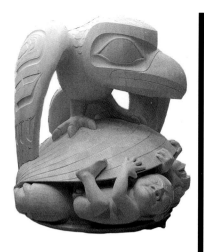

THE RAVEN AND THE FIRST PEOPLE

AS THE RAVEN scanned the beach, "a white flash caught his eye, and when he landed he found at his feet, half buried in the sand, a gigantic clamshell. When he looked more closely still, he saw that the shell was full of little creatures cowering in terror of his enormous shadow. "WELL, here was something to break the monotony of his day. But nothing was going to happen as long as the tiny things stayed in the shell, and they certainly weren't coming out in their present terrified state. So the Raven leaned his great head close to the shell, and with the smooth trickster's tongue that had got him into and out of so many misadventures during his

why such elaborate constructions have evolved. Rather than seek out ready-made nest holes, magpies have in effect acquired the knack of constructing their own.

Although building a roof to deter robbers seems entirely "reasonable," reason, of course, had nothing to do with the development of this complex behaviour. There was no Wise Old Magpie in some legendary time past that solved the problem in a burst of insight and passed the new and improved nest design on to her descendants. Instead, as evolutionary theory has it, the urge to build roofed nests arose through a random change in some ancestral magpie's DNA. Since her chicks were more likely to survive than those from open nests, her genes—and her nest-building behaviour—spread through the population. The blueprint for the domed nest was written into the intricate code of the magpie's inheritance.

Instinct and Insight Nest building provides a classic
example of instinct in action, as each species runs through the behaviours that are hard-wired into it. Crows automatically build crow nests, jackdaws build jackdaw nests, and so on. But still there are surprises. Sometimes the birds *do* seem to have a sense of what they are doing. Konrad Lorenz, for example, tells the story of a pair of captive jackdaws that chose a very small box to house their nest. At first, the male bird busied himself with carrying hefty twigs for the foundation. "But the nest-box was so small that there was scarcely room for the nest-cup itself. The female (the architect of the nest-cup) appeared to grasp this fact. In any case, she repeatedly ejected the twigs which the male had collected and herself carried in soft nest-material—mainly straw and newspaper." The finished nest consisted of a cosy cup with no supporting bowl or platform, just what was needed in this novel circumstance.

40

Although male and female jackdaws (like most corvid pairs) usually share the task of building the nest, in this case the efforts of the male were "almost exclusively disruptive."

Another careful observer, Lawrence Kilham, encountered a similar debacle at a crow nest, which was being constructed by an adult pair and several unhelpful immature "assistants." Eager but uncoordinated, this crew could manage only a tumble-down mess. Finally, the breeding female took over the project and reworked the materials into the standard crow-nest plan. The other birds then returned and added the final touches.

In the same vein, corvid expert Derek Goodwin tells of his observations at a rook nest. Rooks often seem clueless in the early stages of construction, bringing in sticks that are impossibly large or impossibly small and trying to wedge them into places from which they are sure to fall. If they notice that a stick is slipping, they will try to save it, but if it hits the ground, they won't bother to pick it up. Instead, they'll laboriously obtain a new stick and carry it all the way back. Yet when a completed nest fell apart (sending two of three young chicks to their death), the adult birds were able to reconstruct it using only twigs, with no lining material. In other words, they improvised a repair. As Goodwin points out, "It is difficult to interpret this behaviour as lacking in insight and purposiveness." The bird apparently knew what had to be done and set out to do it with the least possible expenditure of effort.

But how can nest-building behaviour be both rigid and, at least partially, flexible? How can it be both determined by genetics and modifiable by intelligence? The psychologist Jean Piaget had a suggestion. In a 1971 book, *Biology and Knowledge*, he proposed that instincts, or innate abilities, are not just physical reflexes but also

troubled and troublesome existence, he coaxed and cajoled and coerced the little creatures to come out and play in his wonderful, shiny new world."

—Bill Reid and Robert Bringhurst, *The Raven Steals the Light*, 1984

PAGES 42 AND 43:
The north wind doth blow and we shall have snow, and what does the gray jay do then? Sometime in February, this resident of the boreal forest begins to build its nest, an ultra-well-insulated structure of twigs lined with a thick layer of lichens, plant down, moss, fine grasses, fur, and feathers. The adults collect such materials for months before they start work on their nests, just as if they understood the need to attain high R-factors.

LEFT: WAYNE LYNCH;
RIGHT: JAMES M. RICHARDS,
VALAN PHOTOS

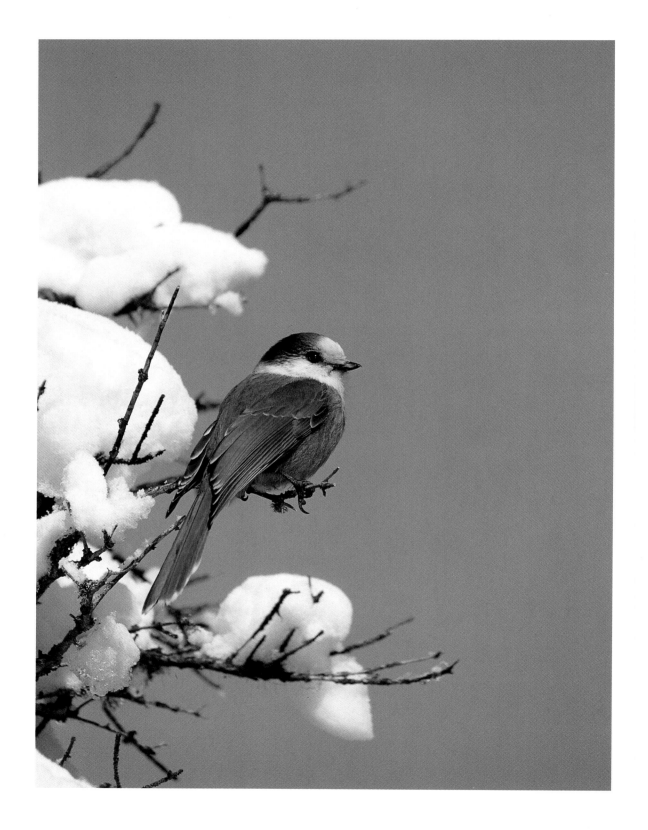

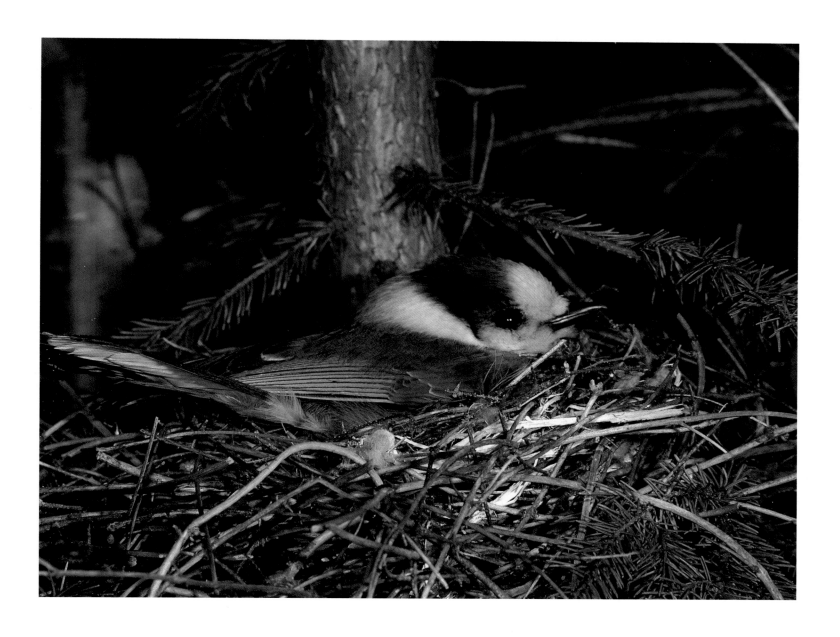

43

inherited knowledge. For example, a crow may be born with a "schemata," or mental representation, of a nest, which it attempts to realize through its actions. But this mental template is not immutable. Within limits, it can be creatively altered to meet the needs and circumstances of the individual. The smarter the bird, the more latitude it has to modify its inherited patterns by using its brain power.

Decisions, Decisions

Take, for example, the case of the pinyon jay. A native of the foothill and plateau country of the western United States (especially the pinyon pine woods from which it takes its name), this jay is notable both for its soft, shimmering plumage and for its sociable nature. Pinyon jays live in clamorous flocks of several hundred birds that nest colonially in stands of conifers. Ordinarily, each tree bears a single nest, which is built and used by a single breeding pair.

The exact site of the nest in the tree—high or low, sun side or shade side, exposed or concealed—is determined by the male partner, which entices his mate to accept his decision by carrying sticks to the site and then, if she follows him, offering to feed her there. Should he choose an open spot, the nest (and the incubating female) will enjoy the full heat of the sun and thus avoid the worst effects of low temperatures and soggy late-winter snow. But as the nest and nestlings bask in the sun's warm glow, they will also lie exposed to the eyes of hungry ravens and crows. Thus, the male might be better off to select a location that is shielded from sight, even if it means giving up the warm sunshine.

To make the problem even more complicated, neither the weather nor the population of predators is stable. A nest site that provides the perfect compromise between sunshine and safety in one season may fail miserably a few years later if the climate takes a turn for the worse or the number of ravens in the area suddenly increases. This means that if

the birds' nest-site selection was predetermined once and for all, they would often be out of sync with prevailing conditions. But if their choices were based partly on their natural inclinations and partly on what they observed, they could respond more flexibly to changes in the world. Under such conditions, "natural selection may favour the ability to learn about these [variable] factors."

This idea was advanced in the early 1980s by John M. Marzluff, a researcher at Northern Arizona University. To test his unorthodox hypothesis, Marzluff spent the next six springs climbing to 282 pinyon jay nests. As he swayed around in the treetops, sometimes 30 m (100 feet) up, he noted the identity of the breeding males (which were individually marked with coloured leg bands), the precise situation of the nests and, eventually, the broods' failure or success. In general, Marzluff discovered that the younger, inexperienced males chose wide-open, sunny spots. If all went well, the birds made a similar choice for their next attempt. But if they lost their eggs to predators two or three times, they began to show a preference for lower, more sheltered sites. To be precise, "the frequency of nesting in exposed locations dropped from 80% to 55% after individuals suffered their third predatory experience when nesting in exposed locations." Most jays had reached this point by the age of four or five.

Within the next couple of years, by age seven and up, the birds achieved another refinement. Although they continued to nest low in the trees for greater concealment, they now began to inch out towards the ends of the branches. This was especially true of nests that were built in late winter and early spring. These slightly more exposed sites provided the birds with access to a few extra rays of sun without greatly increasing the risk of predation.

"The process by which jays select nest sites appears to involve

many forms of learning," Marzluff told readers of the sober scientific journal *Animal Behaviour*. For one thing, individual birds seem to remember and benefit from their own experience. For another (and here he speculated), they may learn by observing other breeding pairs. On warm afternoons late in the nesting period, groups of adult jays sweep through the colony on what seem to be "nursery visits." As the birds stop to peer into each other's nests, perhaps they take note of the factors—light, shade, elevation, warmth—that are associated with large broods of noisy nestlings, the hallmarks of success.

Eggs and Afterwards

Pinyon jays and other corvids lay medium-sized clutches, seldom fewer than three or more than six. They are produced at intervals of roughly a day, usually in the early morning, and are then incubated for about two and a half weeks. Typically, the female serves this long, tedious watch alone, except for the regular offerings of food that her partner brings to the nest.

The female's primary task is to nestle closely over the eggs and transfer her body heat to the embryos inside. To facilitate this process, she develops a "brood patch," a bare area of skin, swollen with blood vessels, that appears on her belly. But incubation calls for more than a warm body. It also requires a keen attention to detail. A female raven, for example, doesn't just plop down on her eggs; she first tucks them carefully into the soft cushion of the inner nest lining, by working under them and around them with her beak. As each egg begins to pip, she turns it head-side up. Then, when the chick struggles out of the shell, she eats the debris, cleans the bedraggled youngster and sometimes nudges its neck onto a nearby egg for support.

Once the nestlings have hatched, the female keeps a close eye on them for another two or three weeks. If the weather turns cold, she snuggles

FACING PAGE: *From the outside, a crow nest may look like a sprawling heap of sticks. But, as this bird's-eye view reveals, the interior is exquisitely crafted.*
WAYNE LYNCH

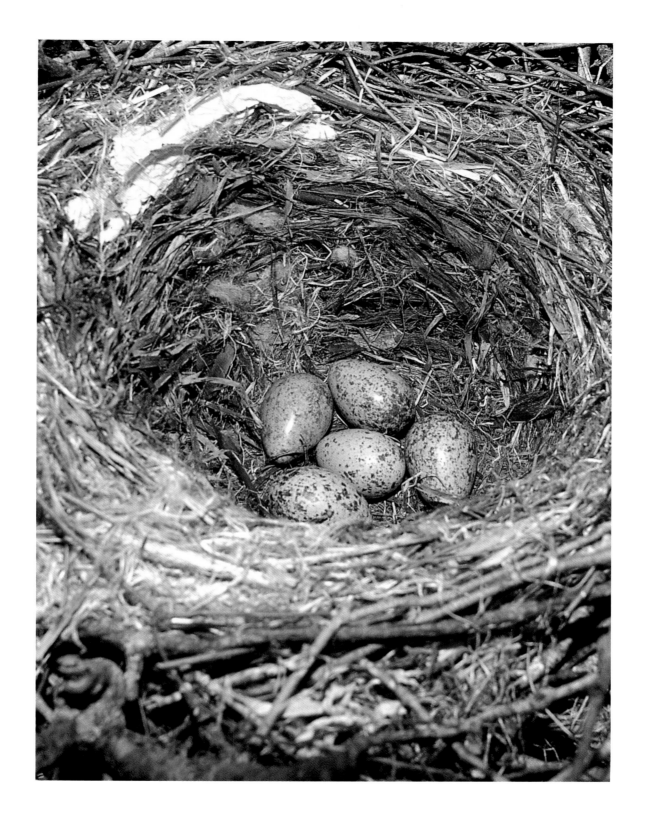

them down into the insulated nest lining. If they are panting with heat, she may splash into a pond or stream and then stand over them, wet and dripping. Alternatively, she will work an opening in the nest, as if to admit a welcome breath of air. Is this instinct? Insight? A little of both? One way or another, as Bernd Heinrich puts it, it looks "very much as if the birds 'know' what they are doing." He himself once watched as a raven spent twenty minutes poking around in its soggy nest, for all the world as if it were trying to drain it.

The care with which adults feed their chicks also bespeaks a finely tuned sensitivity. Jackdaws are known to match their food deliveries to the age and capabilities of their nestlings. Thus, a male that had carried whole worms to his mate during incubation began tearing them into little bits to feed new hatchlings. Several days later, he began to bring in whole food again, presumably in response to signs that the chicks were prepared to take on bigger challenges.

Who's Who? As long as the youngsters stay in the nest, the adults appear to regard them as anonymous mouths to be fed. If an experimenter swaps chicks from brood to brood, the adults don't seem to care, or even to notice. They busily stuff bugs into any chick that is put in their care. Food goes into the gape that squawks loudest, stretches highest or occupies a favoured position, without any concern for individual fairness. Although the parents rarely or never feed other birds' young, their attachment is to their nest and its contents, not to the chicks themselves.

But once the youngsters fledge, everything changes. No longer able to identify their young by their location (that is, in the nest), the adults suddenly acquire an ability to recognize them as individuals. For example, adult magpies may lead their newly fledged chicks to an area in

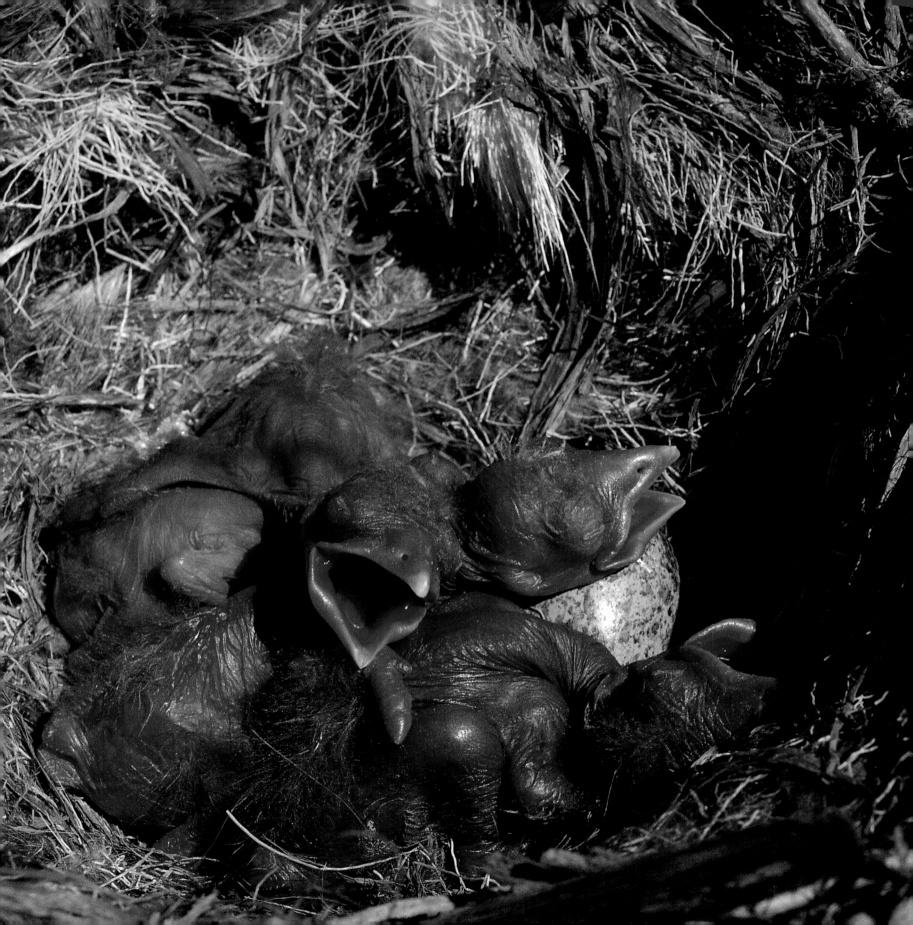

which food is abundant. As other families fly in to share the resources, the birds form a cohesive flock of up to eight broods. Although the fledglings beg for food whenever an adult comes close, the adults ignore the clamouring of all except their own young.

To human eyes, at least, one scraggly magpie fledgling looks pretty much like the next. So how do the adults tell them apart? Do they pick up on visible differences that we can't detect, or do they recognize their young in some other way? Experiments with pinyon jays suggest that parents and young recognize each other primarily by voice.

Pinyon jay chicks leave home at twenty-one days of age and join other fledglings from the neighbourhood in a grouping called a "crèche." These are mobs of forty to sixty youngsters that include offspring from several nests. By the time the fledglings band together, each of them has learned to recognize the calls that its parents utter when they bring food to the nest. (In playback experiments, the young jays react much more strongly to their parents' squawks than to those of other adults.) Yet when an adult jay approaches a crèche with food, the young birds all go into paroxysms of vociferous begging. (Who cares if it's my parent, as long as I get fed?) The adults, however, are more exacting. Although they occasionally give food to strangers, they almost always brave the tumult of the crèche, find their own progeny and offer food only to them. Again, playback tests show that the adults recognize their offspring by their begging calls. What's more, analysis of these calls suggests that they permit personal recognition ("That's Jenny; that's Fred"), rather than just establishing a family resemblance ("That one's mine; that one's someone else's").

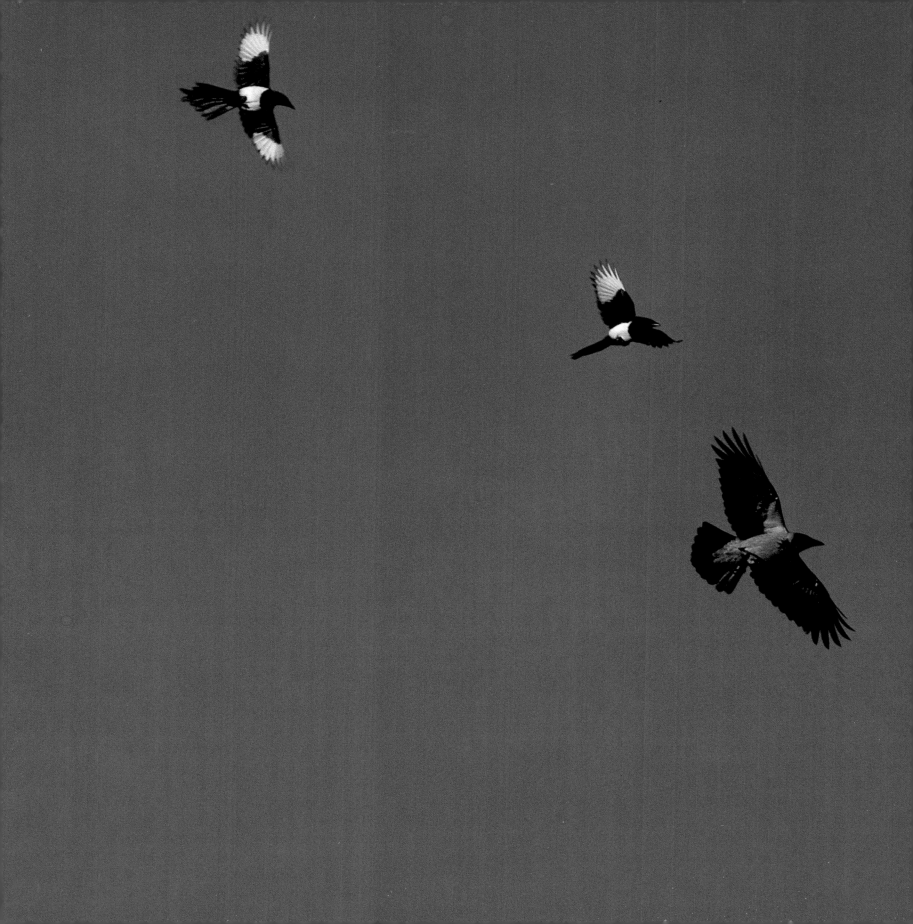

School Days With the adults literally on call to provide nourishment, the fledglings are free to take a bright-eyed interest in the world around them. Their main business in life is to learn, and their main teachers are their parents. As Lorenz observed in his jackdaw colony, young corvids sometimes follow the lead of their elders with utter confidence: "I would never have believed that such blind trust in the example set by the parents could conceivably be present." Through imitation, the juveniles learn basic survival skills, such as how to travel safely through their home range. To his surprise, Lorenz discovered that the birds follow traditional routes that are passed from one generation to the next. Thus, when he set a batch of hand-raised chicks together with an experienced adult, the young jackdaws quickly adopted the flight ways of their mentor. Indeed, they took over the older bird's pathways so exactly that they continued to avoid the parts of the garden where the family cat liked to hunt. Yet that cat had died long before these youngsters hatched.

As Lorenz and other observers have noted, fledglings often seem pathetically dependent on adult guidance. Young jackdaws that lack a leader flap enthusiastically away from their home colony and get lost, never to be seen again. Young magpies, a day or two out of the nest, go into a panic over a falling leaf yet fail to take cover when a hawk soars overhead. Some of them pay a high price for their incompetence. In one study, more than a fifth of magpie fledglings fell prey to owls, hawks and falcons within two weeks of leaving the nest. The lucky survivors thus have good reason to learn fast. By taking their cue from the adults, they quickly figure out when to hide and when it's safe to relax.

Biologist Deborah Buitron, who watched the goings-on at more than two dozen magpie nests in South Dakota, observed what she thought might be "anti-predator lessons." A whole family of magpies would take off after a coyote or a crow, harassing it with machine-gun blasts of loud, "rattling" calls. Yet these exercises were conducted late in the breeding season, when the fledglings were no longer at serious risk from such predators. Thus, Buitron proposed, this behaviour "may serve primarily to teach the young which species are dangerous." A similar function has also been proposed for "mobbing," the noisy daredevil attacks in which gangs of magpies, crows and other birds (often in mixed flocks) go after hawks, owls and other fearsome creatures.

Apprentices at the Nest?

Several corvids, including American and northwestern crows and a dozen species of New World jays, permit immature birds (often one- or two-year-olds) to serve as "helpers" at their nests. Some observers have wondered if these youthful assistants are actually apprentices, practising skills they will later use in their own nesting attempts. Carolee Caffrey, for example, watched at American crow nests that were attended by two adults and one to three yearlings, mostly the daughters of the breeding pair. "I have observed helpers literally following in their parents' footsteps," she says, "manipulating discarded nesting material, sitting next to and watching their parents during nest building, being thwarted by breeders as they attempted to feed nestlings inappropriate items, and jostling with the breeding female for the opportunity to brood eggs and nestlings."

Among the drably named but far from drab scrub jays of Florida, such observations are relatively common. About half of all breeding pairs are accompanied by helpers (sometimes as many as five), most of which are sons from previous clutches. In their first season of nest duty, these youngsters initially spend their time watching as older birds feed insects to the chicks. After several days of this, the apprentices go through the motions in pantomime, "feeding" the nestlings from empty beaks. In time, they will arrive at the nest with tiny scraps of food and, finally, with meal-sized portions. If they serve a second year (or a third or a fourth) as helpers, their efficiency will increase with their experience. A three- to five-year-old helper often outdoes the parents in providing nourishment.

Pairs of Florida scrub jays that employ helpers raise more than twice as many fledglings as those that manage without. (In addition to bringing in food, the helpers also defend the nest with reckless

THE RAVEN AND THE FLOOD

IN THE Babylonian story of the Flood, which predates the biblical version, the raven is the bird that succeeds in finding dry land. In this passage the Babylonian Noah, Uta-Napishtim, tells what happened:

"When the seventh day had
 come
I brought out a dove and let
 her go free.
The dove flew away and
 [then] came back;
Because she had no place to
 alight on she came back.
I brought out a swallow and
 let her go free.
The swallow flew away and
 [then] came back;
Because she had no place to
 alight on she came back.
I brought out a raven and
 let her go free.
The raven flew away, she
 saw the sinking waters.
She ate, she pecked in the
 ground, she croaked, she
 came not back."

intensity, and this may be their main contribution to the welfare of the brood.) Even so, biologists suspect that the helpers themselves are the main beneficiaries of the arrangement. Not only do they pick up a good education (or so it seems), but they also enjoy privileged access to the resources and safety of their parents' territory. For a young bird that can't make its way in the world because nest sites or partners are scarce, moving in with Mom and Dad may be the best option. As for the parents, letting junior hang around home may be a last-ditch attempt to secure the future of a hapless youngster. As Alexander Skutch puts it in his book *Helpers at Birds' Nests*, it's "all very human-like behavior."

As far as we know, corvids cannot think their way through such complex dilemmas. Nevertheless, they do somehow make assessments and arrive at decisions: to leave home or become a helper, to reject would-be assistants or tolerate them. The flexibility to make these choices is, of course, programmed into the birds through their evolutionary inheritance. But the enactment of one behavioural "program" instead of another calls, at the very least, for discernment of the individual's unique circumstances. Thus, when a young Florida scrub jay tours the neighbourhood without finding a vacant territory or a mate and then flies back to its parents and signs on as a nest assistant, it has, in some way, appraised its chances of breeding and made a choice. Exactly how a bird does this is, and may always be, beyond our own much-vaunted intelligence. But we are at least smart enough to guess that *something* must be going on inside those feathered heads.

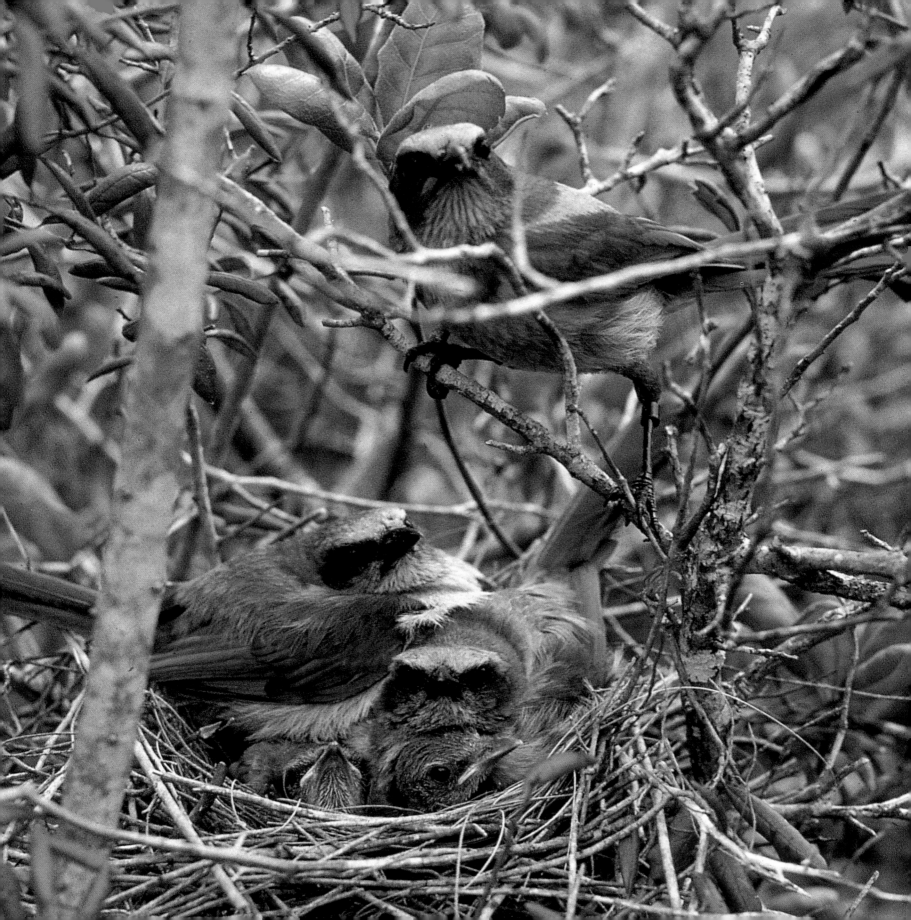

One of the most difficult of all things to endure for a crow, a raven, a wolf, or a human is to feel alone and separated from one's own kind. A sense of belonging is one of the most universal of all feelings.—LAWRENCE KILHAM, 1989

Belonging

Very smart animals tend to be very sociable. One thinks of humans, dolphins, whales, parrots—and corvids. Of the crows and crow relatives that have been closely studied, all have proven to be more or less gregarious. Indeed, some populations spend their entire lives in contact with other birds (mostly kin) that they may recognize as individuals or, at least, as companions.

Consider, for example, the Mexican jay, a scrub jay look-alike that inhabits the oak forests and wooded canyons of Mexico and the far southwestern United States. Typically, Mexican jays live year-round in flocks of about six to eighteen birds, most of which are close relatives: grandparents, parents, siblings, cousins, uncles and aunts. Like a pack of wolves, this avian clan cooperates to claim and defend a joint territory. Within their domain, as many as five

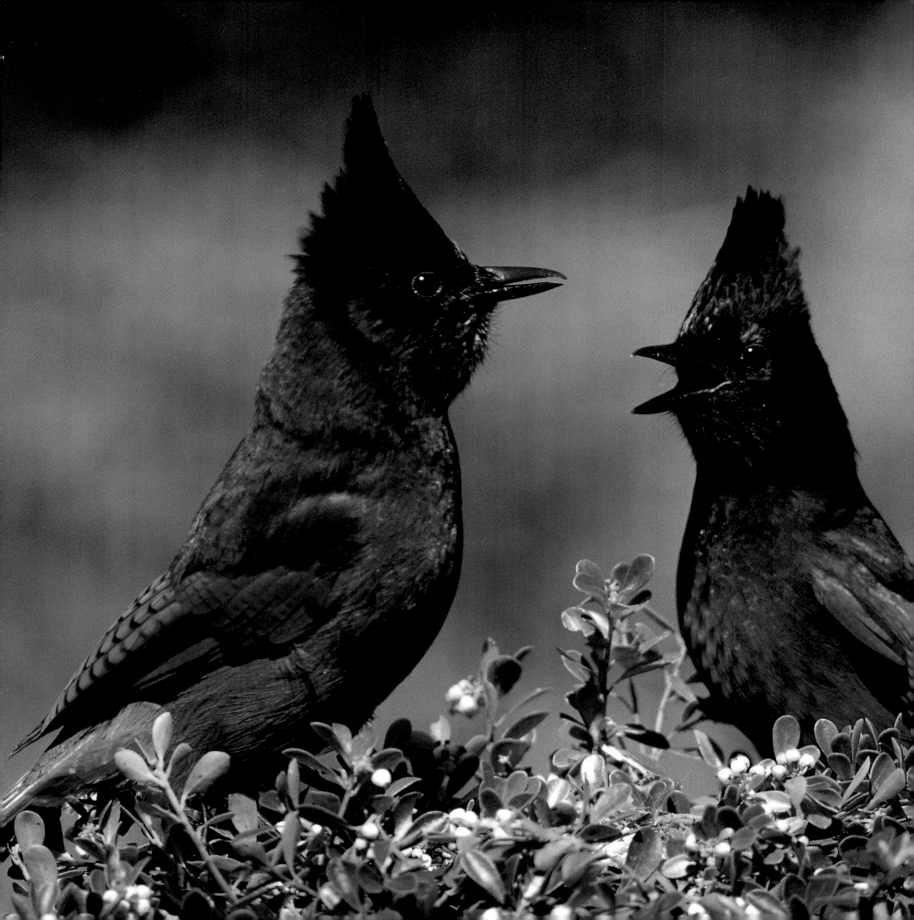

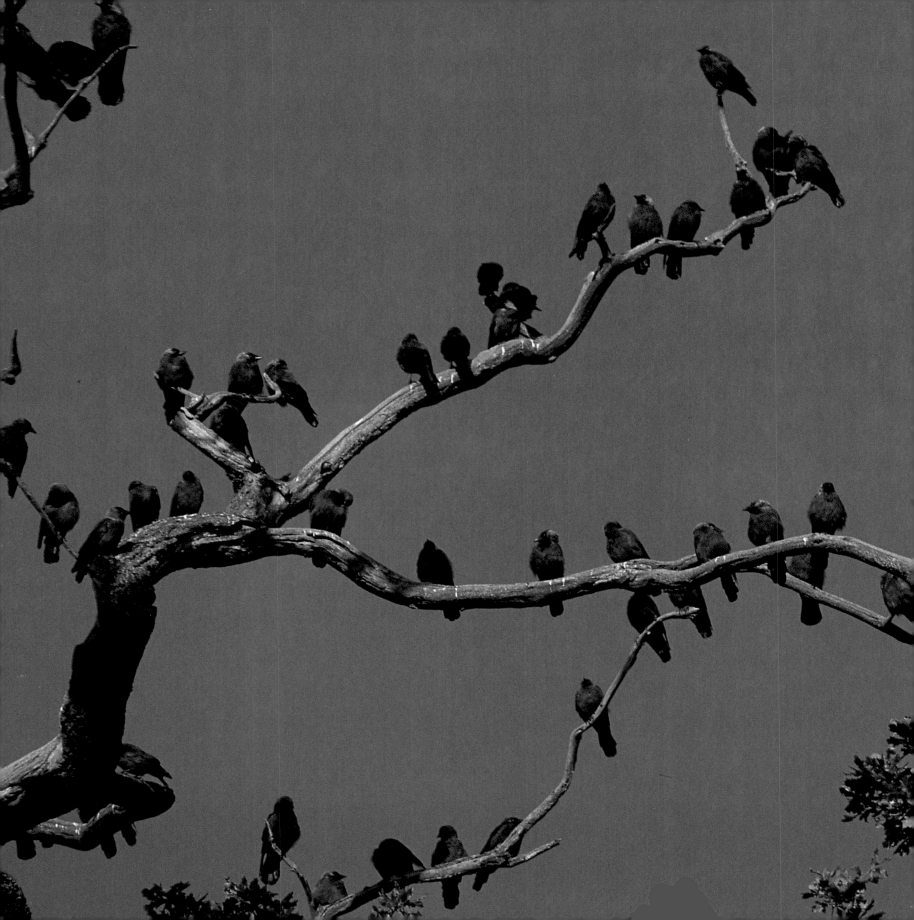

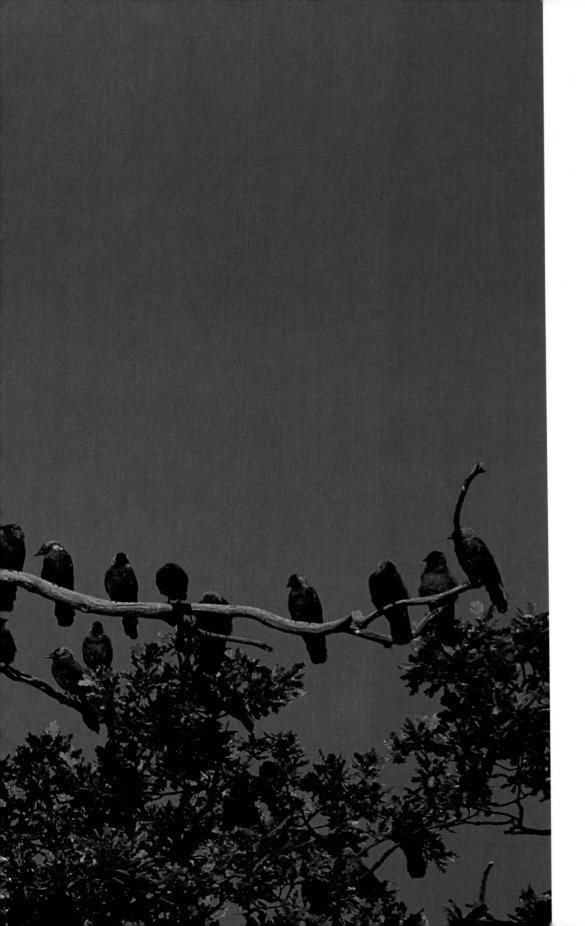

Among the most gregarious of corvids, jackdaws live in society all year round, nesting in colonies, feeding in flocks and resting at communal roosts like the one shown here. One advantage of group living may be that each individual can learn about sources of food by observing and copying its associates.

pairs may build nests in a given spring. In the weeks before the nestlings hatch, the flock is stressed by family tensions, as the breeding birds filch material from each other's nests and even eat one another's eggs. But once the young appear, harmony is restored, and flock members work together to feed their squalling progeny. Although parents concentrate on tending their own offspring, nonbreeding birds bring contributions to each of the nests more or less indiscriminately. And why not? In a flock of Mexican jays, it's all in the family.

Family is also the defining concept in the social life of many other corvids. The large breeding flocks of pinyon jays, for example, are composed of extended families that are linked through "marriage." According to John Marzluff and Russell Balda, who have charted the genealogy of a pinyon jay flock for more than two decades, the birds' society can best be described in terms that are usually reserved for primates: "Pinyon Jays live in troops consisting of numerous clans." In the fall, several such troops, each consisting of a few hundred birds, aggregate in vast flocks of many thousands. Even so, the original groupings are not significantly disrupted. When the large flock disbands, the troops reform with few changes to their membership. To quote Marzluff and Balda again, this is possible because "flock members recognize each other" and choose to remain in one another's presence.

Some experts on intelligence see a likely connection between superior brain power and this sort of intense social interaction. Social animals, they say, must be "natural psychologists," able not only to recognize and remember their mates and companions but also to discern and interpret subtle shadings in their appearance and behaviour. These subtle shadings—the tone of a call, the contour of the head feathers—permit an individual to read the mood and intentions of its associates. The ability to seize such meaningful details from a hubbub of meaningless activity

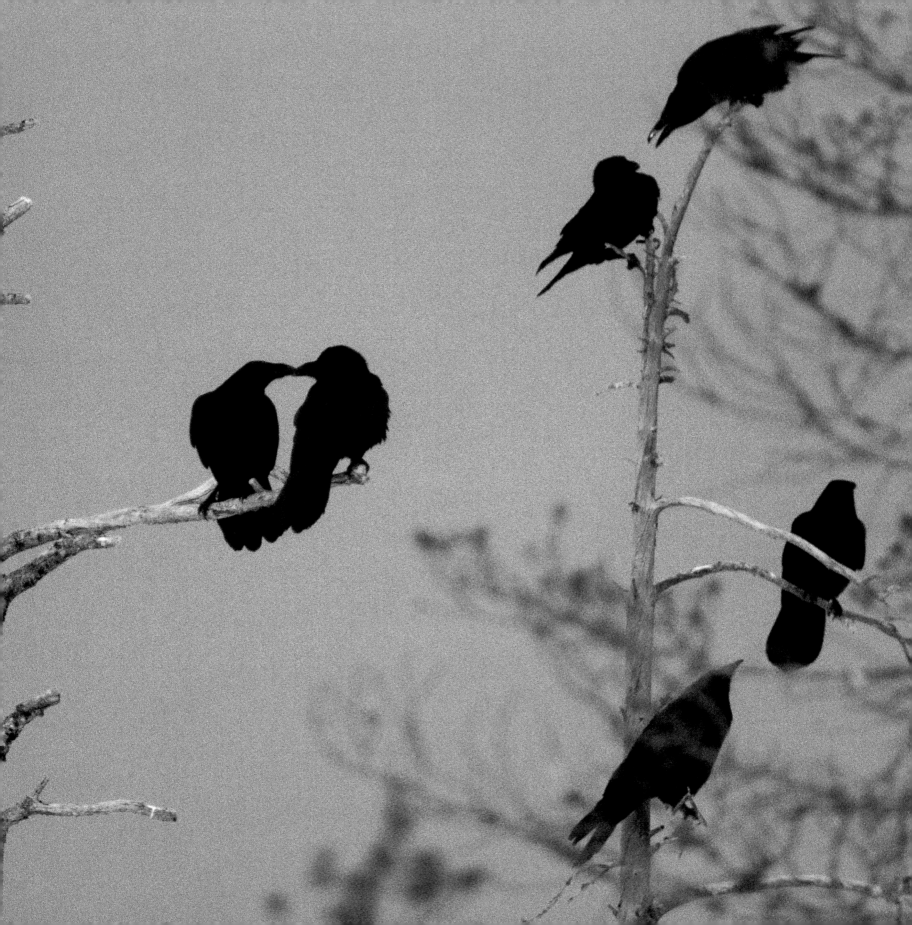

(leaves rustling, feathers ruffled by the breeze) seems likely to be a *mental* ability. If this is true, it applies not only to such extravagantly social species as the Mexican and pinyon jays. It must also be true of corvids that organize their family lives in somewhat simpler ways.

Most crows, ravens, magpies and jays are raised in what we might recognize as "nuclear families." Generally, each adult pair defends a breeding territory from which all other mature birds are forcibly excluded. Social life is therefore focussed on a small core group of familiar individuals—Mom, Dad and the kids. But at nightfall, the picture often changes. Then, any adult that is not tied down by nest duties or territorial defence is likely to slip away to join other adults at a "roost." These are loose aggregations of crows, rooks, jackdaws, ravens or magpies, sometimes in mixed-species flocks, that settle together in groves of trees to spend the night. In the fall and winter, when more adults are free to join, these gatherings sometimes become gargantuan. A roost near Munich has been known to accommodate more than 1 million rooks, jackdaws and carrion crows. Two sites in the central United States (one each in Oklahoma and Kansas) regularly attract even larger numbers: an estimated 8 million to 10 million American crows. That should be enough night life for anyone!

Ganging Up

The social life of a typical corvid varies from season to season and even from day to night. It also changes as the bird passes through different stages of life. Although breeding adults may keep pretty much to themselves, members of the younger generation are generally more gregarious. As we have seen, a few individuals of a few species stay home and help their parents, but most young corvids head off, never to return, several weeks after they fledge. Some of them—young ravens, for example—will not be mature and able to breed until they are three or four. In the mean-

In the olden days, the raven and the peacock were close friends who lived on a plantation in Vietnam. One day, the two birds decided to amuse themselves by painting each other's feathers. The raven set willingly to work and so surpassed itself that the peacock became, as it is today, one of the most beautiful birds on earth. Unwilling to share its glory even with its friend, the mean-spirited peacock painted the raven plain black.

time, they have a living to earn, and to get it, they often need one another's assistance. A youngster foraging on its own cannot stand up to a pair of adult ravens. This means that a juvenile raven that finds a carcass or other rich source of food will likely be sent packing by the resident birds. But if the younger individual is accompanied by eight or nine other young toughs, the adults will have little choice except to cede the carcass.

In a series of elegant experiments, Bernd Heinrich was able to demonstrate that young ravens actively recruit one another's help. In one instance, he set out a carcass and, over it, broadcast recorded raven "yells"—the excited shouts that juveniles give when they locate such a food bonanza. Twenty seconds later, a raven flew out of the forest, inspected the prize and left. Within two minutes, twenty-nine ravens streamed into sight, arriving from the direction in which the first bird had gone. None of these birds landed—ravens are initially timid around large carcasses—but the next morning, forty ravens whooshed to the site (presumably from a nighttime roost), alighted and fed. This happened in Maine where ravens are rare and, apart from such experiments, seldom sighted.

As Heinrich is careful to point out, the birds could have followed one another to the food without any conscious intention either to recruit or to be recruited. But it is difficult to imagine how they could have arrived en masse without a measure of crafty awareness—the exuberant cunning for which Raven has long been celebrated.

Playtime "Teenage" ravens don't spend their whole lives scrabbling over food. Like most other young corvids, they also take generous breaks for what looks to be fun and frolic. Until quite recently, the dry-bones of science insisted that birds never played. At most, the experts said, birds experienced random and uncoordinated firings of their reflexes, little more than behavioural twitches. But this position has been now been

revised, largely through a consideration of crows and their allies. As a group, corvids are recognized as the most playful of birds, much given to games for one player such as drop-and-catch, hang-upside-down-under-the-branch and balance-on-the-flimsy-perch. Occasionally, they invent complex social games, such as tug-of-war or king of the castle. (In the latter, one bird stands on the top of a mound and brandishes a small stick, while its playmate charges towards it and attempts to grab the object.) Sometimes their play even reaches out to engage a member of another species. For example, a young raven developed a game with a dog, in which bird and mammal—apparently reading each other's gestures and signals of intention—took turns chasing one other around a tree trunk. Ravens have also been known to play catch-me-if-you-can with wolves, a challenging pastime in which the birds are always at risk.

If corvids are the most playful of birds, young ravens are said to be the most playful of corvids. Although most of their games are solitary rather than interactive, several birds may practise the same sport at the same instant. Thus, if one raven slides down a snowbank or a piece of wood, all the other birds in the group will likely follow suit. If one hangs upside down from a wire and passes a piece of cheese from its foot to its beak and back again, another may line up beside it and try to do the same. This means novel behaviours that are created by one individual are quickly learned by its associates. For ravens, as for humans, youthful goofing around is an innocent way of testing and extending one's physical limits. Through play, the individual acquires a repertoire of complex movements that it may later be able to employ in the complex circumstances of real life.

Does creative play of this sort require intelligence? Alternatively, is play a mental exercise that enhances brain power? According to Millicent Ficken, in her paper on avian play, "the answer is probably both." Writing specifically of ravens, she says, "Because they are intelligent they are capable

of diverse and complex play activities." At the same time, through play they probably "learn relationships with the environment that contribute to their plasticity of behaviour and great ecological success in many different habitats." Play is serious business.

Showing Off Play may also serve another important purpose of

adolescence—attracting a desirable mate. So far as is known, corvids choose their partners for life. Once a pair has formed, the birds may be separated by death but seldom by divorce. Thus, if an individual chooses badly, he or she is stuck with a lifetime of consequences. But how is a female to know in advance if a juvenile male that she meets in a group of nonbreeding birds will feed her when they're both adults and she's incubating their eggs? Reciprocally, how is a male to tell if the female will have the wit to protect her chicks from spring blizzards? The birds need ways to assess one another's "fitness," and playtime may be one of the forums in which they have a chance to make these judgements.

In his book *Ravens in Winter*, Bernd Heinrich tells the story of a tame female raven, misnamed Edgar, that took scant interest in her human female keeper. But when a macho ex-serviceman moved into the house, Edgar (who was as confused about her species as her namer had been about her sex) followed the man around "like a puppy." What's more, for the first time ever, she displayed "a variety of 'tricks' "—lying on her back while holding objects in her feet, wrapping spoons and clothespins in paper and even soliciting sex by vibrating her tail. Play was her way of showing off to impress someone whom, in her bewilderment, she saw as a potential mate.

Showing off also seems to be a preoccupation of young male ravens—and perhaps of male corvids generally. In a study of carrion crows, Norwegian biologist Tore Slagsvold found that male crows fought with one another for an opportunity to attack his stuffed eagle owl. It looked as if they were

competing for the privilege of showing off, though Slagsvold could not tell if their derring-do won favour with female crows. Female ravens, however, do seem to prefer fellows with brave hearts. As Bernd Heinrich suggests, ravens that lead other birds to unusual—and therefore frightening—sources of food are courted, whereas those that merely follow are less desirable. Thus, he concludes, an unmated raven that finds food likely "invites eligible singles to join him (or her?) at the feast, thereby not only gaining or maintaining access to the food, but possibly also increasing its status and demonstrating fitness as a future provider for rearing offspring."

Heinrich suspects that ravens' spectacular airborne play may be another way in which juveniles strut their stuff before the eyes of potential mates. Flying half loops, full loops and double loops—often in breathtaking combinations—is no doubt fun, but it also "weed[s] out lazy birds and poor flyers."

> The general explanation for these flights with acrobatic rolls and "rrock" calls is play. Undoubtedly the birds are motivated by immediate enjoyment. But play is not an explanation from an evolutionary perspective; it has a function. I wonder whether the social play of ravens isn't similar to a dance where teenagers get to know each other. Doing the raven "rrock" and roll may be another version of doing the twist and shout.

Weighing the Options
For most species of corvids, little is known about the qualities that the birds desire in their sexual partners. But in the much-studied pinyon jay, there is evidence to suggest that females prefer males with bright plumage and are generally unimpressed by size. The males, in contrast, mate with the heaviest females they can attract. Because male corvids are dominant over females, choosing a large female may be a way of equalizing the power relationship in the "marriage." This seems to cut down on marital squabbles and increase nesting success. The jays also prefer partners of about the same age.

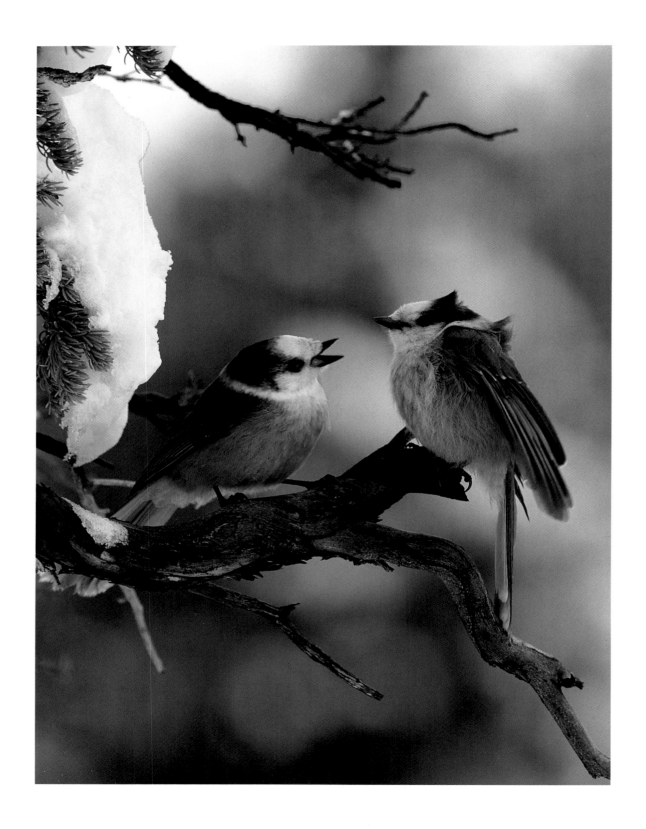

These relatively simple factors—colour, size and age—seem to be especially important when the birds choose their first mates. But the second time around (typically after a death), the considerations appear to become more subtle. Now the jays are likely to show a preference for suitors that have bred successfully in the past, perhaps basing their decision on their "memory of past events." As researchers Marzluff and Balda explain, the jays may "monitor" one another's performance when they go on nest tours or when the fledglings congregate in crèches. If they cannot obtain a partner with a proven track record, they apparently look for someone of a similar age and, failing that, of an attractive weight (again, males prefer heavy females, but females like lightweights). Thus, the birds somehow not only assess but also prioritize a hierarchy of factors that, in part, are different for each sex.

Bereavement

"Ceremonial" gatherings following the death of a mated bird have been reported for a number of species of corvids. For example, if a magpie loses its partner early in the breeding season, the event is marked within twenty-four hours by a noisy gathering of visitors. Is this a magpie funeral, as has sometimes been assumed? Or, as seems more likely, are the well-wishers really opportunists in the market for a mate or a vacant territory? (Generally speaking, a bereaved female corvid will be displaced by an invading pair, whereas a male is able to hold onto his land and attract a new mate there.) By the time the noisy crowd disperses, the vacancy has usually been filled in one way or another.

But if these "ceremonies" are not outpourings of grief, there are other indications that corvids may experience distress at the loss of a mate or a close companion. In *Ravensong: A Natural and Fabulous History of Ravens and Crows*, Catherine Feher Elston writes about her pet crow, Gagee, who took on the task of feeding and caring for an injured fledgling. When the

FACING PAGE: *The affectionate intentions of this pair of gray jays are obvious even to a human observer. Gray jay courtship involves bill-rubbing "kisses" and gifts of food from the male to the female partner.*
THOMAS KITCHIN

young bird died, the usually garrulous Gagee was stone silent for four days. Similarly, Konrad Lorenz tells of a captive jackdaw that, he surmised, gave voluble expression to her feelings. When all the other members of her colony escaped, she retired to the top of the weathercock and sang nonstop. To Lorenz's attuned ear, her calls were "heart-rending." "It was not how she sang, but what she sang" that was so moving: "Kiaw, kiaw, kiaw"—come with me, fly home.

Some corvids are even able to call a missing mate by "name." Members of several species, including American crows, common ravens, rooks, Eurasian jays and pinyon jays, are known to develop individually specific calls, which often include sounds they have learned through imitation. A distraught bird may call for its absent partner by mimicking its unique call. (One female raven, separated from her mate, suddenly began to utter sounds that she had not used since youth but that he had been using all along.) If the mate is free to return, it will immediately come home.

Corvid Want a Cracker? Many species of corvids
have a talent for mimicry. A perfectly ordinary blue jay may suddenly scream like a hawk or caw like a crow. A Eurasian jay may interrupt its usual calls to utter a magpie's chatter or a cricket's rasp. One group of field biologists was drawn out of their tents by the sound of a whistled reveille, only to discover, first, that it was four in the morning and, second, that the wake-up call had come not from their supervisor, as they had supposed, but from his cage of pet jays. In captivity, corvids may also develop a knack for mimicking human speech. Thus, a tame raven named Macaw greeted his keepers by calling, "Hellomacaw," a reiteration of the phrase with which they greeted him. In the same way, Konrad Lorenz's pet raven, Roah, used his own name, uttered in "a mock human voice," as a call-note for Lorenz. "The exact imitation of my pronunciation of his

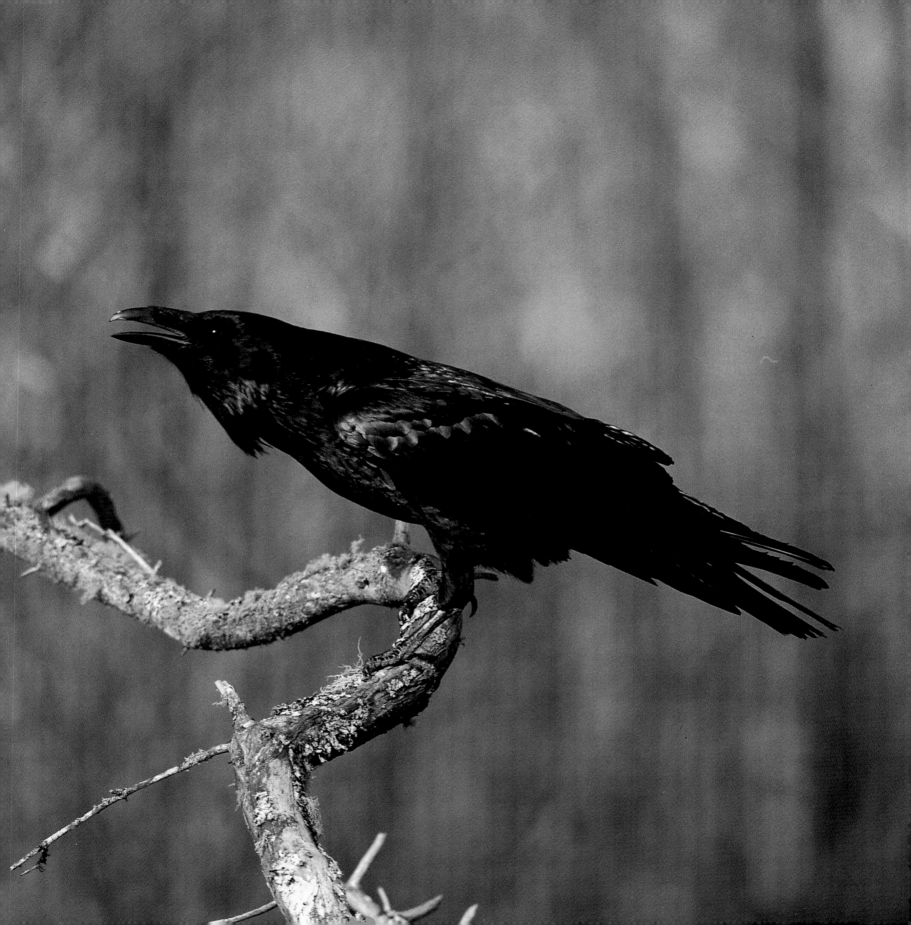

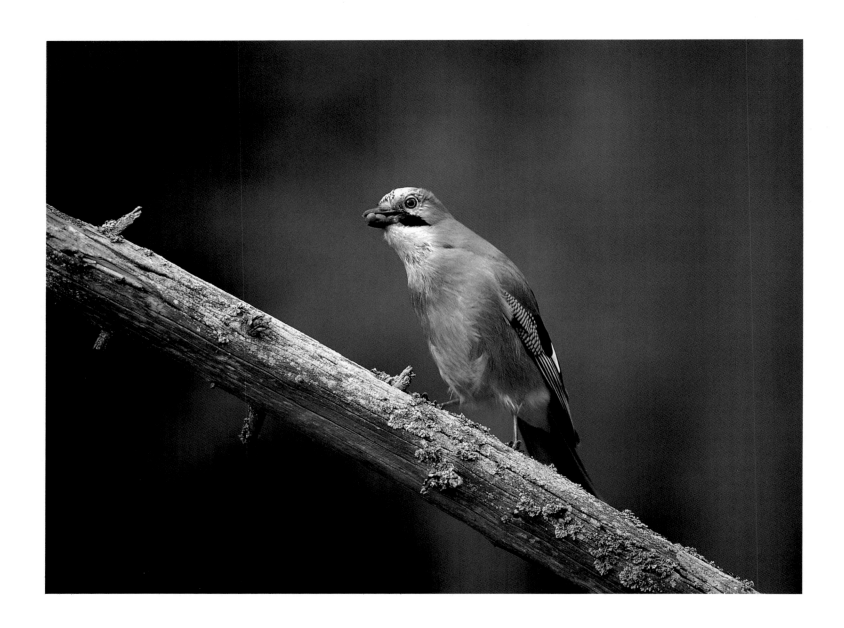

name is extremely startling," Lorenz noted at the time; "starting with a friendly tone, he passes in a smooth transition to a commanding and eventually irate tone."

As Lorenz points out, the old raven must have "possessed a sort of insight" that identified the sound "Roah" as his keeper's personal call-note. "Roah is, so far as I know, the only animal that has ever spoken a human word to a man, in its right context," he wrote. But another tame raven on record regularly spoke a human word to another raven. Having heard the German word *komm* when he was called for a meal, the bird used the same sound to call his mate to be fed. Apparently, corvids sometimes form mental associations between sounds and the circumstances in which they are heard.

Derek Goodwin noticed that his captive Eurasian jays scolded him by repeating words and whistles they had learned from him. When a dog ran through the garden, the jays often barked; they miaowed at the sight of a cat. "At such times," Goodwin recalls, "I was reminded of a small child greeting an animal with an imitation of its cry." He also heard wild jays croaking like herons as gray herons flew overhead and imitating tawny owls while mobbing them.

Most amazing of all, an observer named H. Löhrl once followed a flock of jays as they flew to a tree where a tawny owl often roosted. "Not finding it, some of them uttered imitations of its hootings before they flew off to another owl roost to mob the bird there!"

Song Circles
Although corvids occasionally use mimicked sounds in a meaningful context, their powers of imitation have been put mainly at the service of social togetherness. The imitative abilities of corvids (like those of parrots, mynas and other "talking birds") appear to serve as what scientists call an "intragroup bonding mechanism." In other words,

To some listeners,
the wild, musical
voice of the Siberian
jay seems specially
attuned to the bright
beauty of the northern
forest. Both Siberian
and gray jays are
noted for their ability
as vocal mimics.

HANNU HAUTALA

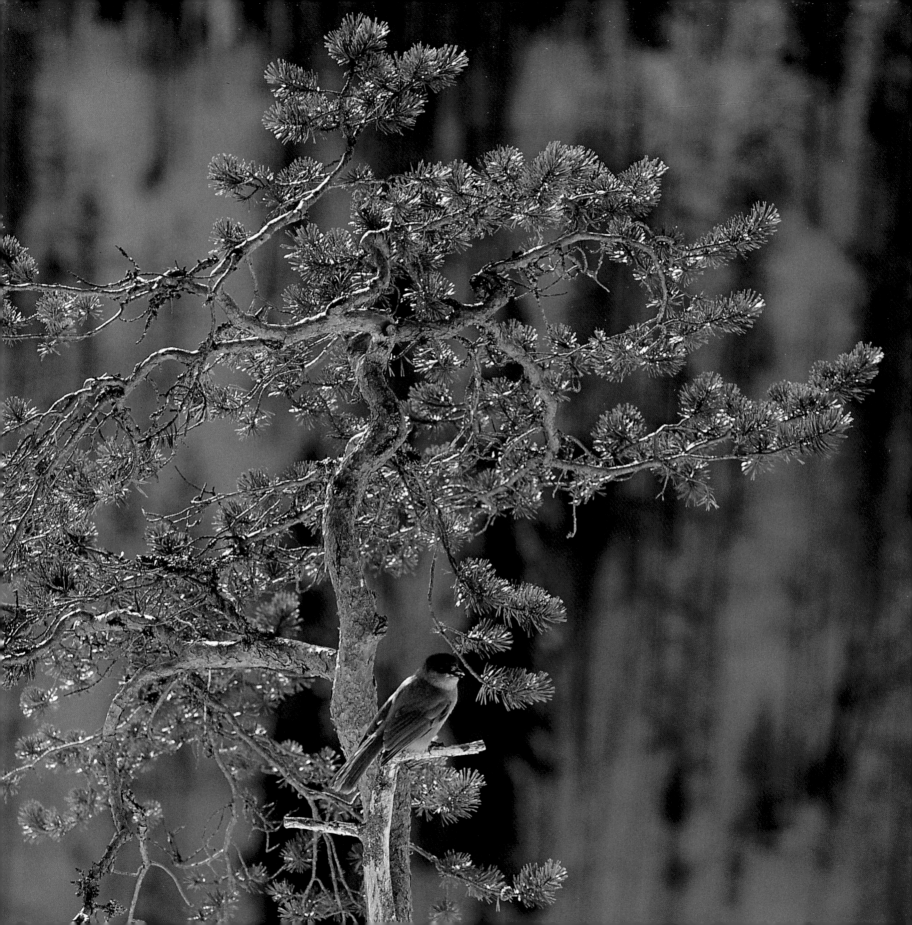

crows that squawk together flock together. The more song elements two birds share, the stronger are the social bonds that connect them, and vice versa.

Every corvid has a tuneless "song," a rambling monologue that includes imitated sounds together with mumbled renditions of its everyday caws, coos, screeches, rattles, clicks and chirps. Among American crows (one of the few species to be closely studied in this regard), it appears that each social group uses a particular set of elements in its song—some the same as those of its neighbours, some different—which members share through imitation. If two members of such a group are particularly attached to each other, they tune their songs even more closely to each other's.

In one experiment, for example, two young crows were housed in the same cage, where they spent hours singing duets, often standing a few centimetres apart and uttering the same sounds, with the same actions, at almost the same moment. If they were separated for a few minutes while feeding, they burbled happily together as soon as they were reunited. If they had a spat, a few phrases of tuneless song restored the harmony between them. When not singing, they liked to preen each other's feathers, a sure sign of crow affection. But when a strange crow was placed inside their cage, the best friends snootily rejected her, pecking and poking at her and excluding her from their companionable singing. This went on for the better part of ten weeks—until the outsider learned to imitate the "coo" calls of her associates. Once her renditions were perfected, the resident crows cosied up to her and let her take part in their mutual grooming. In the view of Eleanor Brown, the zoologist who conducted the study, the development of a "shared group repertoire" likely provided the basis for this enlarged fellow feeling.

The solidarity among members of a crow singing circle may extend beyond simple companionship. Crows are known for their acts of kindness to injured and ailing members of their species. In one well-documented case, a mated male northwestern crow regularly brought food to an unmated female that was handicapped by deformities and partial blindness. This association lasted for at least two breeding seasons, even though the male was simultaneously pressed to feed young chicks in the nest. ("During 1635 minutes of observations" by a precision-minded team of biologists, "the male fed the young 66 times and the deformed female 24 times, while [his mate] fed the young 89 times.")

Unfortunately, it is not known if the helper and the helped were relatives or long-time friends. Konrad Lorenz says that ravens will only come to the rescue of known companions, but this assertion has not been rigorously tested.

The Language of Corvids

Although corvid song often includes imitated sounds, it is primarily composed of the birds' "natural" calls. These, of course, vary from species to species—crows caw, ravens croak, jays scream, magpies chatter. Like the whimpers, sighs, giggles and shouts of a human being, these utterances are not learned but come as part of the organisms' species-specific genetic package, in which each call has a preassigned function. Thus, Eurasian jays mew querulously when they are hungry and murmur tenderly when they come to offer food. They screech when they are alarmed and pant huskily if they intend to attack. American crows are even more versatile, with an estimated vocabulary of more than two dozen separate vocalizations: assembly calls, scolding calls, dispersal calls, threat calls, contact calls, hunger calls, feeding calls and many more. At least some of these sounds appear to correlate with specific moods (of peacefulness or aggression, for example) and may serve to communicate these feelings to other birds. Ravens—which probably produce a greater variety of sounds than any other animal except ourselves—are variously estimated to have between eighteen and sixty-four recognizably different kaa's, kruk's, krrk's, nuk's, clucks, rattles and trills, which presumably permits them to express a variety of meanings.

The "language" of corvids has been a favourite subject for study and comment for millennia. Yet as Bernd Heinrich laments, "I'm convinced that there is nothing that we know less about." The innate and supposedly stereotyped calls of ravens, for instance, have turned out to be confusingly variable. In the end, it may well be revealed that birds in Maine speak a different dialect of Ravenese from those in Alaska or Wyoming or Germany. Perhaps this explains why a list of calls that is compiled in one area never coincides neatly with one developed in another region.

It also seems likely that the standard quorks and croaks of a species' repertoire are subtly altered by the individual's emotions and its circumstances. In her study of the anti-predator behaviour of magpies, Deborah Buitron discovered that the birds' alarm calls varied sensitively

The Raven

"Ghastly grim and ancient Raven wandering from the Nightly shore—Tell me what thy lordly name is on the Night's Plutonian shore!" Quoth the Raven, "Nevermore."

—verse by Edgar Allan Poe, illustration by Manet

FACING PAGE: *Quoth the raven, "Quork." To a sensitive ear, raven vocalizations seem to be inflected by the emotional state of the bird. For example, researcher Bernd Heinrich notes that courting birds sound tender, whereas combatants sound fierce. "It surprises me ... [that] the raven's calls sometimes display emotions that I, as a mammal for whom they are not intended, can feel."*

TOM WALKER

with the degree of danger that the birds perceived. If the magpies saw a falcon perched in a tree, they swooped at it with loud, long rattling calls; but if the predator took off—thus posing an immediate threat to its pursuers—the volume and intensity of the call increased to a siren-like wail of staccato shouts. It is tempting to think that other magpies in the vicinity formed an idea of what was happening by hearing and interpreting these meaningfully graded calls.

American crows *are* known to respond appropriately to their neighbours' alarm calls. A crow that hears or sees a predator at a safe distance will utter a relatively slow barking caw, and other crows will drift in—half flying, half gliding—to investigate. (If the malefactor is not in view, the vigilantes will poke around in the trees as if searching for it.) When, in contrast, a large owl or a hawk is detected at close range, the alarm is sounded with loud, long, angry caws, and crows fly hard and fast to join in the mobbing melee. Perhaps the crows form mental images of the probable danger, based on past experience, and approach with a knowledge of what is likely to happen. (Remember the jays that hooted at the vacant owl roost?)

To date, our attempts to intercept and interpret corvid communication have been ham-handed. It's as if aliens were to land among us and record our conversations as we eat breakfast, quarrel over the morning paper and head off to work. Later, in the antiseptic comfort of their sonographic labs, they chart the rise and fall of our voices and note correlations between our actions and our inflections. But they miss the meaning, the emotion, the awareness, the will to be understood—the very essence of human communication. Perhaps we are doing an equivalent disservice to crows and their relatives.

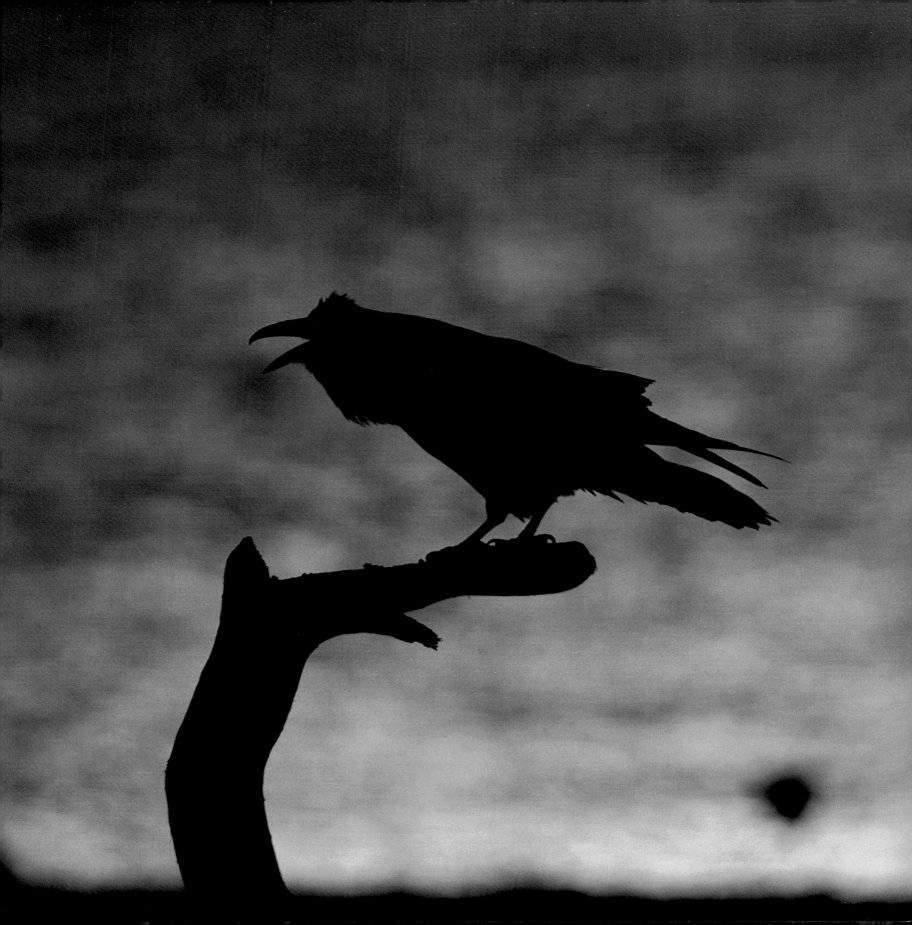

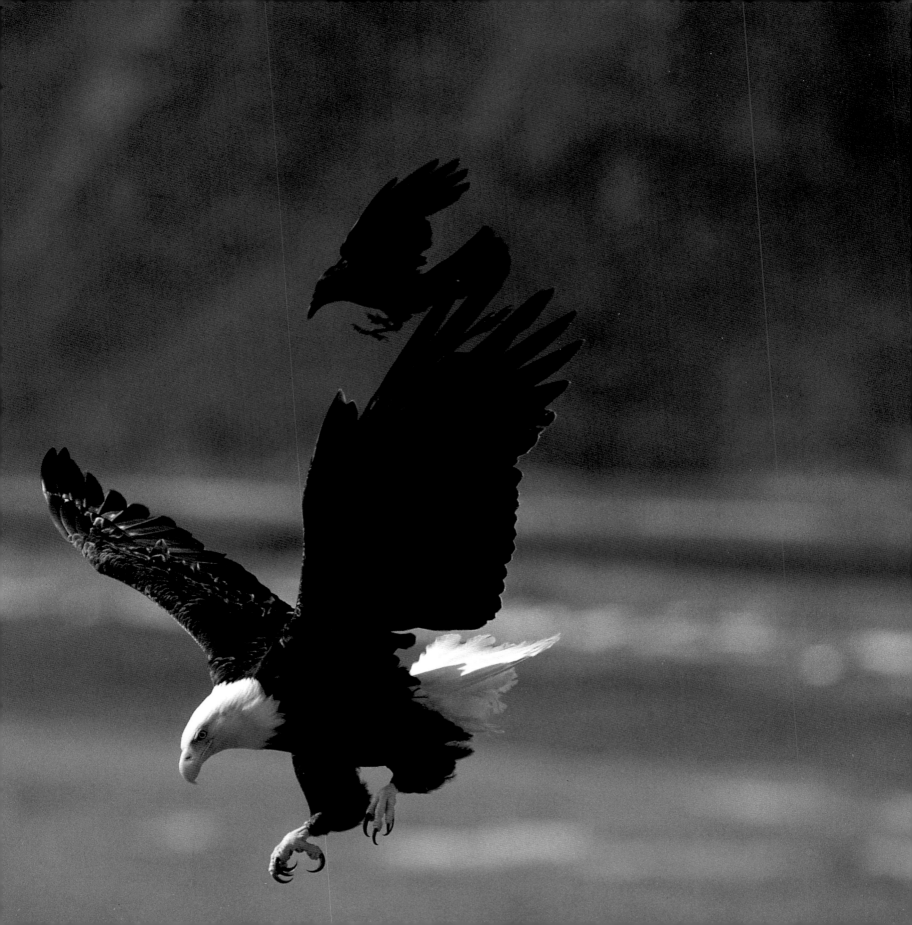

An animal

may be considered to experience a simple level of consciousness if it subjectively thinks about objects and events.—DONALD R. GRIFFIN, 1991

Bread and Butter Issues

Brainy animals, like people and crows, tend to take a carnal delight in food—flower and fruit, fish and fowl, animal and vegetable. They are often "generalists," able to identify and exploit a wide array of nutritional resources. Whereas a specialized animal may be able to get by with low mental wattage (just enough to permit it to recognize a few preferred foods), a generalist has to run a regular inventory on dozens of edible items, an occupation that calls for curiosity, perception, memory and, often, inventiveness. For such an animal, a well-stocked brain may be an essential means to a well-stuffed belly.

Most species of corvids have wide-ranging tastes in food. Almost all are omnivores (like ourselves) and typically seek food both in trees and on the ground—seeds, nuts, berries, caterpillars, grasshoppers, frogs, field mice, birds' eggs, nestlings, garbage, carrion and other

delicacies. The birds appear to be born with an innate ability to recognize and acquire some of these items. Eurasian jays go through a stereotyped (and presumably inborn) routine when they catch wasps, which involves capturing the insect and then biting repeatedly near the stinger to disable it. Jays do not have to learn the hard way to avoid this hazard. But they are nonetheless highly capable of learning about other dangers in their food supply. For example, when a captive jay was fed two species of grasshopper, one poisonous and one safe, the bird hungrily gobbled up both of them. But once was enough. Even though the insects were ingested together, the jay somehow identified the culprits and thereafter refused to eat them any more, although it continued to welcome the more palatable kind.

It seems likely that the foraging behaviour of many corvids is largely shaped by experience. Their education may well begin in the nest, as they become familiar with the items their parents bring to them, and continue during the weeks when they hang around home as fledglings. Young jays, for example, are not born knowing about the relationship between small acorns and mighty oaks. When they first see oak seedlings, the birds take no interest in them. But once they notice adults obtaining nuts from beneath the plants, the youngsters begin to pull at all sorts of vegetation. In time, either through trial-and-error learning or closer observation of their parents, they learn to restrict their efforts to oaks and, even more specifically, to the first-year plants that are most likely to yield edible cotyledons.

Even as adults, corvids are constantly on the lookout for clues about what's on today's menu. To obtain up-to-the-minute information, they keep a sharp eye on other members of their flock or family group. Has one of them found a feast that could be shared? Has someone found a smaller prize that could be stolen or duplicated? Crowd around and take a

94

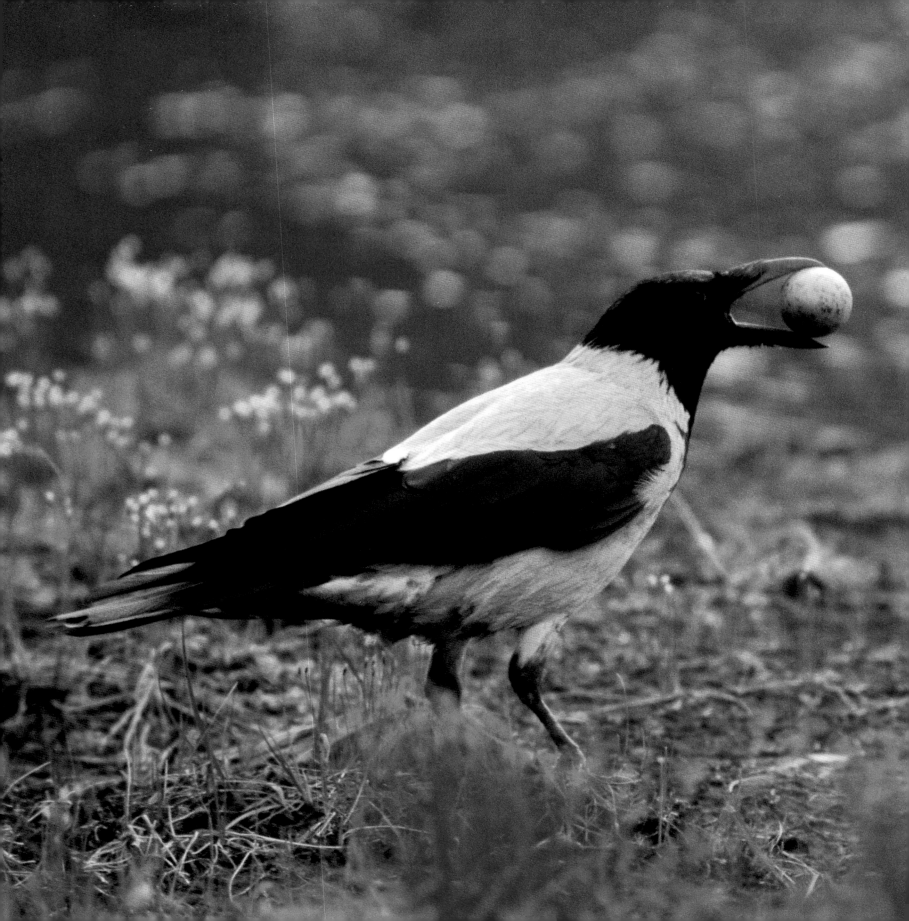

look. Don't stand back; it pays to be curious. If one of your companions flies strong and hard away from the nighttime roost, follow it eagerly in the hope that it is heading for food. When a flustered songbird rages and swoops at you, take it as a sign that it has eggs or chicks nearby and calmly search the bushes. Watch the ducks come and go from the marsh until you know where to look for their nests. For an experienced corvid, the airwaves are crackling with information.

Search Images
No one knows how, or if, birds think about what they learn. But biologists suspect that they store their knowledge in the form of "search images." In one laboratory experiment, a group of blue jays was trained to peck a key and obtain a food reward whenever they saw a picture of a certain species of moth. At first, the moths were shown against plain cards so that their colour and form could be clearly observed. But later they were pictured in their natural cryptic environment. Even though the insects now blended almost perfectly into the background, the trained jays still picked them out with little difficulty. By contrast, they seldom responded to similar images of a different type of moth, presumably because they had not formed a search image for this species and could not detect it under camouflage conditions.

The classic demonstration of search images was made in 1970 by a researcher with the fitting name of Harvey Croze. On a sandy beach where carrion crows gathered mussels, Croze laid out a row of empty shells, each with a piece of meat beside it. Within a few hours, the crows had found and eaten all these tidbits. The next day, Croze set out another row of shells, only this time he hid the food underneath them. When the crows returned, all they could see were empty shells on the sand, a sight that would not ordinarily spark their curiosity. Yet the birds found, overturned and fed from all but two of them. From a single experience,

they had learned that empty mussel shells could be a sign of food and had apparently formed a search image for them.

Once learned, never forgotten. Even when Croze began setting out shells without meat in them, the crows continued to investigate them now and then. If he baited one at random, the crow that hit the jackpot would suddenly turn its attention to checking empty shells, in a single-minded attempt to strike it lucky again.

The last phase of Croze's experiment, in which the birds were winners and losers by turns, begins to approach the complexity of real-life foraging. It's a game of chance, and the stakes are literally life and death. If you consistently score, you will obtain enough energy to survive and reproduce. But if you lose too often, you burn up more calories in the search for food than you take in from what you ingest. Even crows and ravens, birds that are reputed to "eat anything," have to be selective in their food choices. To do this, they must constantly scan their home range for possible nourishment, like the crows that kept a watchful eye on Croze's mussel shells. Then they must determine which of their options is currently the best bet. (Thus, a crow that found a baited shell immediately put its money on searching for more of them.) And finally, as the source of food on which they are foraging becomes depleted, they must decide when it's time to head for greener pastures. How much energy does it pay to expend on checking mussel shells? At what point would you be better off to search for fruit in the cherry orchard or hunt for insects in the bushes? Somehow, corvids make these choices and make them well.

Optimal Foraging In the words of one expert, studies of foraging behaviour generally imply that "animals are capable of sophisticated behavior involving subtle discriminations and decision-making."

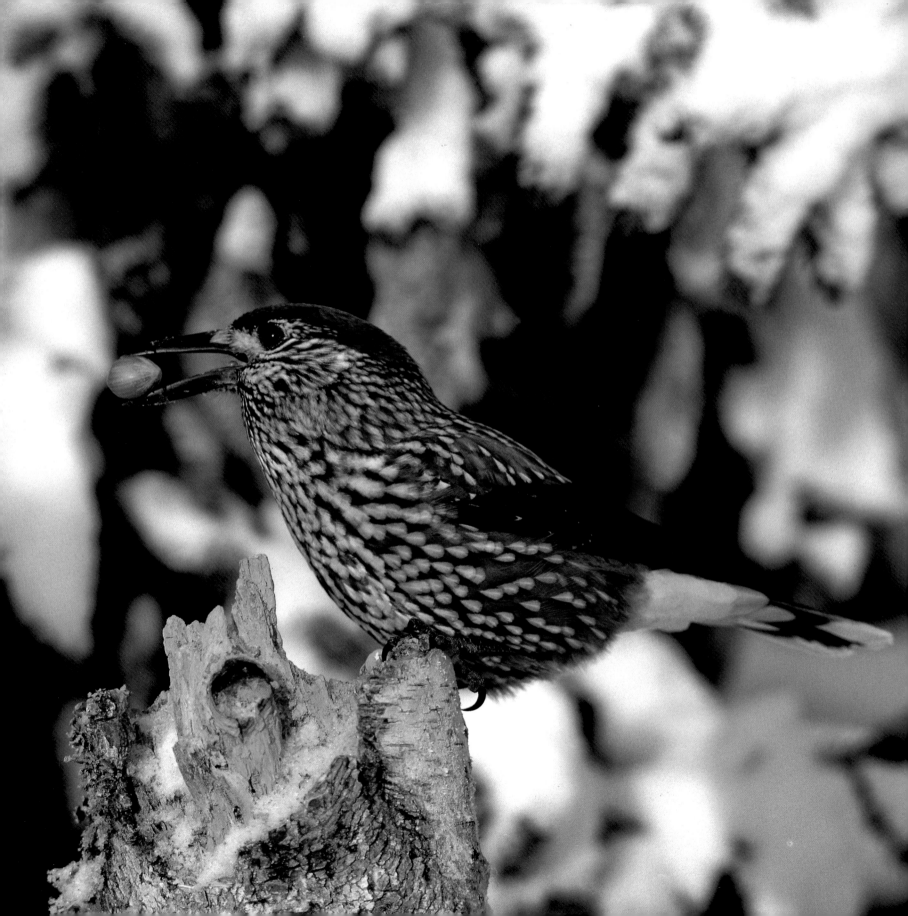

Certainly, corvids choose their food with astonishing shrewdness. Pinyon jays, for example, are able to distinguish nutritious pine seeds from worthless ones by checking them for colour, weight and the sound they make when clicked in the bill. Similarly, Eurasian jays inspect and handle acorns to determine which are large and sound enough to be worth bothering with. If the jays want to transport several nuts to a caching site, they must again rank them by size, with smaller ones being stowed down in the throat and larger ones (too wide to swallow) loaded into the beak. "During close observations" made in Holland, "it was sometimes seen that a jay approached a thick acorn first, made an intention movement to seize it (without touching), went to smaller ones and swallowed these. It then returned to the big one and transported it in the bill without attempting to swallow it." Jays, it seems, are always thinking.

When Reto Zach investigated the feeding behaviour of crows on Mandarte Island, British Columbia, he discovered that they also evaluated food items—specifically, snails or whelks—by size. The crows chose only the heaviest animals, sometimes picking up and discarding several shells before settling on one they liked. Larger whelks had two advantages over small ones, Zach found: they yielded more food and were easier to open. The crows cracked the shells by dropping them on the shore or, to be more precise (as the crows certainly were), on a level floor of rock on the landward side of the beach. Here the shells broke readily on the hard surface and were prevented from rolling into the water by the slope and location of the dropping site.

The crows dropped the shells from an average height of 5 m (16 feet)—the very height that Zach determined from his experiments to be most efficient for breaking large whelks. Had the crows flown higher to make the drop, they would have wasted energy and, at the same time, increased the chance that the shell would bounce out of sight or shatter,

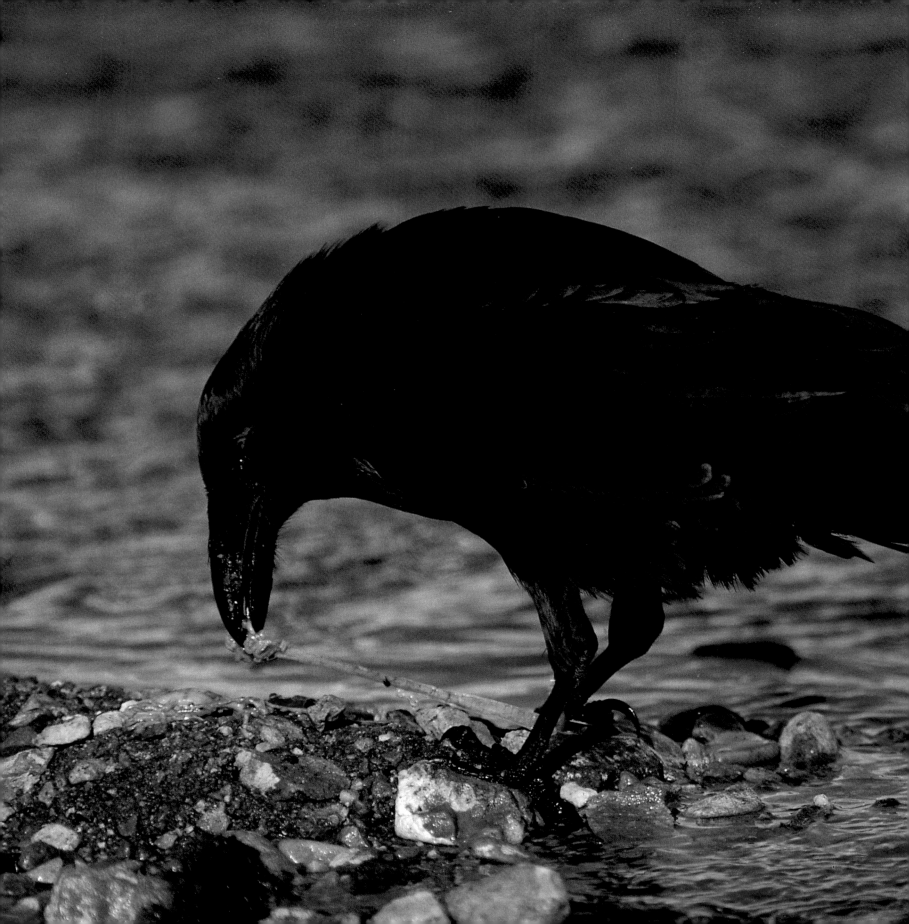

Practitioners of an ancient and irresistible sport, a team of magpies hop up behind a wary-eyed golden eagle. It has been suggested that corvids indulge in this dangerous game as a way of learning about the reactions of their predators.

ANTTI LEINONEN

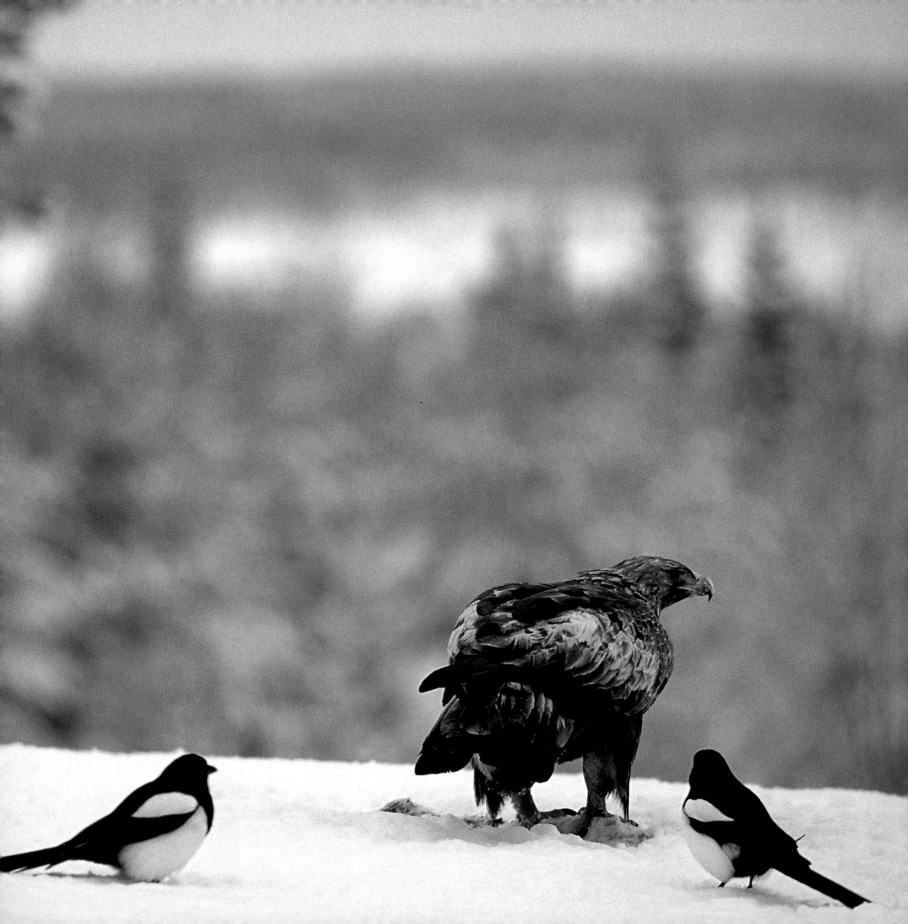

A hunter found an excellent run of seal breathing holes. Then he searched around for a good place to camp. Along flew a raven, which pointed to a certain plain beneath a mountain. "There," the raven said, "all the hunters who come here camp there." The man made his house where the raven indicated. But in the night a big boulder rolled down the mountain and crushed him to death. "I don't know why all these hunters believe my silly stories," said the raven, pecking out the man's eyes.

—A story told by a raven to Nattiq of Gjoa Haven, Northwest Territories, and retold by Lawrence Millman in *A Kayak Full of Ghosts.*

FACING PAGE: *A corvid that loses a round to a predator pays with its skin. These are the remains of a raven that was killed by a goshawk. With better luck than this, a wild raven may live for more than 40 years.*

ANTTI LEINONEN

filling the meat with shell chips. (As it was, "several crows were seen dipping broken whelks in fresh water puddles before eating," as if to rid their meal of unpleasant grit.)

All in all, Zach concluded, the "crows achieved close to the maximum foraging efficiency possible for breaking whelks." The only way he could see for them to improve their performance was by dropping two whelks at a time. And sure enough, one of the crows achieved just that refinement. Without drawing a single bar graph, the crows did everything right.

Team Work
Some species of corvids gain an additional energy advantage by hunting cooperatively. By collaborating with a partner, they are able to take advantage of opportunities they would miss on their own. In one dramatic incident, a man was watching his cat toy with a meadow vole when there was a sudden swish of black wings, and a raven descended like a bolt of lightning towards poor Tabby's head. The terrified cat released the mouse, and at the same moment, a second raven dived down, grabbed the rodent and carried it off into the bushes.

Ravens, magpies and crows all work variations on this hit-and-run scam. Typically, the excitement begins when two or more corvids happen upon a suitable target—an egret with a frog, a vulture with a fish, a wolf with a meaty bone. They then land and, taking no apparent interest in the food, walk around their victim to approach it from behind. Hop-hop-hop, and one of them pecks its rump. Hop-hop-hop, and one of them pulls its tail. When the animal turns to face its tormenters, another member of the team darts in to snatch the food. Ordinarily, whoever grabs the prize gets to keep it for itself.

Sometimes it seems that corvid "teams" are more like gangs of thugs, in which each bird does its best to profit from the efforts of its

Eurasian jays are acorn eaters. In the fall, a typical individual harvests and buries literally thousands of these nutritious seeds, which it then recovers and eats in succeeding months. But a meal or two of meat is a welcome addition to any corvid's winter diet.

JANOS JURKA,
NATURFOTOGRAFERNA/N

The Killing of Grizzly Bear

(This story belongs to the Tsimshian, Haida, Tahltan, Kwakiutl, Nootka and Tlingit people of the Canadian west coast.)

One day, the Raven invited the Grizzly Bear to go fishing with him. Before they went, the Raven secretly caught a salmon and cut it up to use as bait. But when the Bear asked him what he was using, the Raven claimed to have taken his own testicles. He urged the Bear to do the same, and the Grizzly reluctantly agreed to be castrated. As a result, the great Bear died, overcome by the Raven's superior wit.

FACING PAGE: A group of daring magpies shares scraps with a coyote. Corvids are dependent on larger predators to make kills and open carcasses.

companions. But occasionally there are signs of genuine cooperation. A pair of carrion crows that work together to steal eggs at a gullery will often sit down side by side to sup from the same shell. Or one partner may plunge into the water to grab a fish and leave it on the bank for its mate to kill and take to their nestlings. It is even possible that corvids engage in more complex strategies. Pairs of ravens, for instance, are said to practise a clear division of labour when they hunt seal pups. If they find a seal basking on the ice, one partner reputedly will drop into the seal's breathing hole, thus blocking the prey's escape, while the other attempts to drag the pup off and kill it. This report comes to us secondhand from the late nineteenth century, but a recent and reputable observer tells of watching another raven pair that harried a rock dove by driving it back and forth between them. Eventually, one of them had a chance to strike it, and both ravens settled down to pluck it and to feed.

It has also often been claimed that ravens actively solicit the help of other species. This is said to occur when the birds find a large carcass that has not been opened. Unable to tear through the tough hide themselves, they allegedly go looking for a wolf, a coyote or even a person to cut into it for them. By circling, calling and gliding off in the direction of the food, they apparently attempt to guide the predator to the meat, perhaps in the expectation of feasting on the scraps. (A recent witness of just such a performance, ecologist Paul Sherman, was left with "a distinct impression that this bird was alerting me to the presence of a carcass" three-quarters of a mile in the distance.) In the same way, ravens are said to lead hunters to live moose and other large ungulates. These stories are unproven but not discredited.

Using Tools If a tool is defined as a relatively simple device used in performing work, then a bird that picks up twigs to build a nest or

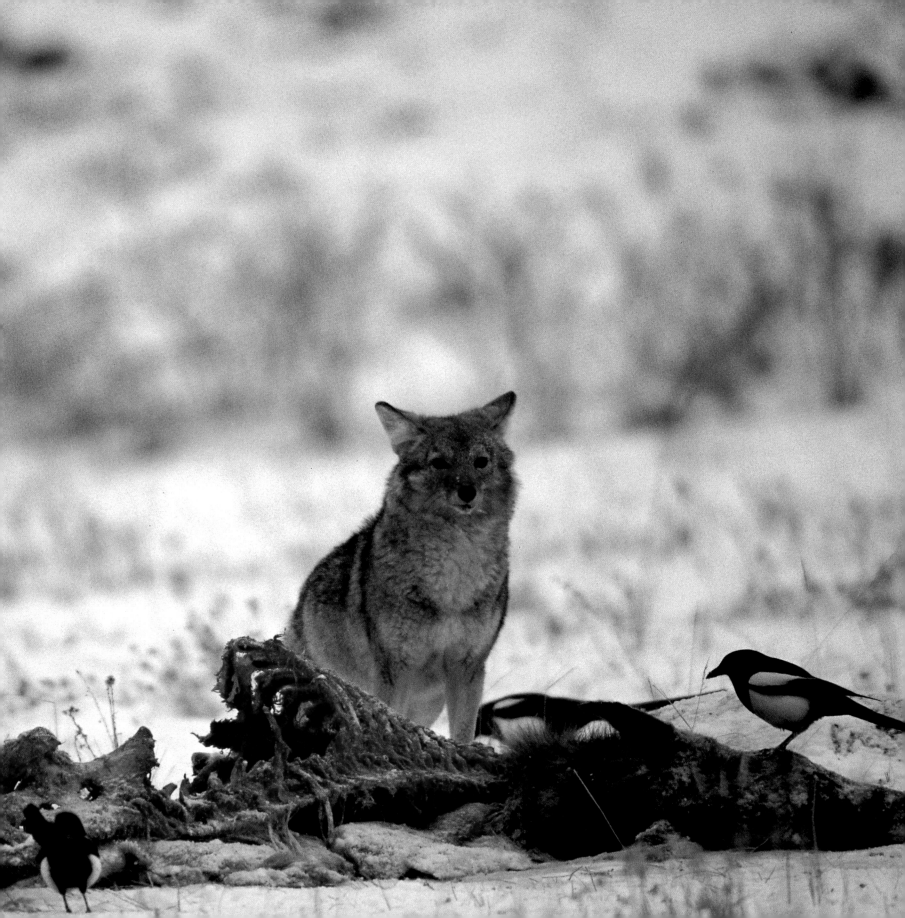

rubs an ant through its feathers to condition them could be considered a tool user. No longer the exclusive attribute of humans, tool use would thus be opened to include most songbirds, such as the corvids. But jays, magpies, crows and ravens would still be entitled to additional credit, for they not only use tools but also invent them.

Consider the case of the blue jay that was housed in the laboratory of two psychologists, Thony Jones and Alan Kamil, at the University of Massachusetts. For the sake of the experiments they were planning, the researchers maintained the jay on minimum rations. One day they noticed something very odd. The jay had picked up a piece of newspaper and worked with it to form a crumpled wad. It had then thrust this object through the wires of its cage and was using it to sweep up food pellets that had spilled on the ledge. As soon as the pellets were within reach, the hungry jay picked them up in its beak and devoured them. The researchers then provided the bird with various objects—a feather, a paper clip, a piece of straw—and the jay was immediately able to make good use of them all. What's more, six other jays in the laboratory subsequently began to use food rakes in the same way, as if they had learned by observing their brilliant roommate.

Blue jays have not been reported to use tools in the wild. But wild scrub jays have been known to select strong forked branches and use them as a vise for holding hard-to-crack nuts. When the nuts are wedged into place, the birds can hammer and pry at them until the shells break. Faced with a similar problem—how to break acorns—American crows will sometimes pound on them with stones held in their beaks. But one individual found a high-tech solution to the tough-nut challenge. Cruising over a busy street, this bird dropped a palm nut from its mouth and then perched to wait until the fruit was hit by a car. As soon as the nut had shattered, the bird flew down to grab a piece of it.

Carrion crows have developed another use for human technology. They sometimes pull up ice-fishing lines to steal the bait or catch. At bird feeders, rooks perform a similar trick by drawing up hanging peanuts or fat that would otherwise be out of reach. This often takes them several hauls, and the bird must secure the string between pulls by holding it with the feet. In one set of experiments, a Eurasian jay routinely obtained food from the end of a string by going through a series of five quick pulls and holds. In another laboratory test, a raven solved a similar problem in just six hours. The fact that this raven never once tried to fly away with the tethered meat suggests it had not only figured out how to pull strings but also had a real understanding of this unusual circumstance.

Hide-and-Seek

Given the ingenuity and energy with which corvids search for food, it is only to be expected that they sometimes obtain more than they can eat in one sitting. When this happens, they respond by tucking away choice morsels for future use. So far as is known, all species of corvids cache surplus food, though they don't all do so in precisely the same way. Magpies, crows and ravens, for instance, occasionally hide their leftovers under tufts of grass or in dense clumps of leaves, but ordinarily they bury food in the ground, working it in with their bills and then covering it with dirt or debris. Often they fetch stones or leaves to place on top of the cache, as an extra protection against the prying eyes of mice, squirrels and, especially, other corvids. The birds seem alert to the prospect of theft and go out of their way to conceal their riches in private. Thus, a raven that is caught in the act of making a cache will unearth its hoard and carry it to a new site, one that is safe from the greedy gaze of would-be pirates.

Like most songbirds, many corvids are thought to have a poor sense of smell, so unless they are lucky enough to see where a cache is placed,

they have little hope of appropriating another bird's riches. But they have no such difficulty in re-appropriating their own. After a lapse of hours or even days, a crow, raven or magpie will fly directly and confidently to its buried treasure, as if locating it posed not the slightest problem. In one study, northwestern crows were observed to find and feed from more than three-quarters of their caches, some of which had been hidden two days before.

Rooks can surpass even this record. These birds have been known to bury nuts in the fall and recover them months later, in the hungry days of midwinter. Similar feats are also commonly performed by several species of jays. A gray jay of the boreal forest may make up to one thousand separate caches on a bountiful summer day but not feed on them till weeks or months afterwards, when it is struggling through the snowbound months of autumn, winter and spring. Although it is capable of hiding food in the soil like other corvids, this jay has a unique ability to glue insects, meat scraps and other tasty treats onto the bark of trees, where they are held in place by gobs of gluey saliva. When the forest floor is drifted deep with snow, the gray jay merely locates and consumes these convenient above-ground meals, complete with their edible packaging.

But other Northern Hemisphere jays have to make it through the winter without any comparable advances in food processing. Eurasian jays and American blue jays, for example, are restricted to typical corvid caching strategies. Although they sometimes tuck food into clumps of foliage or stuff it into crevices, they usually rely on the soil to provide hiding places. Yet even when snow drifts over their caches, the birds still manage to uncover nuts and acorns, sometimes from depths of half a metre (1.5 feet) or more. In fact, they relocate these energy-rich morsels by the hundreds and thousands—enough not only to sustain the adult jays through the winter but also to give the new crop of fledglings a strong

FACING PAGE: *The Siberian jay is thought to share the gluey saliva of its American counterpart. Both species are known to tuck surplus food under loose bark, in clumps of conifer needles and among strands of lichen.*
ANTTI LEINONEN

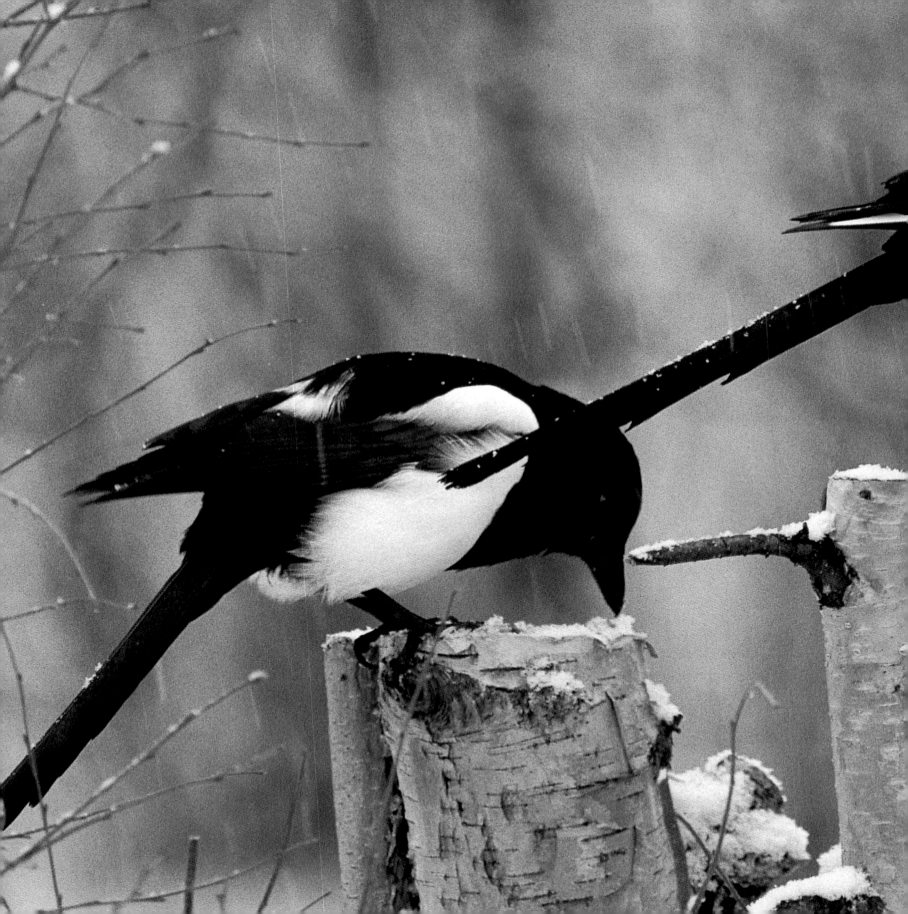

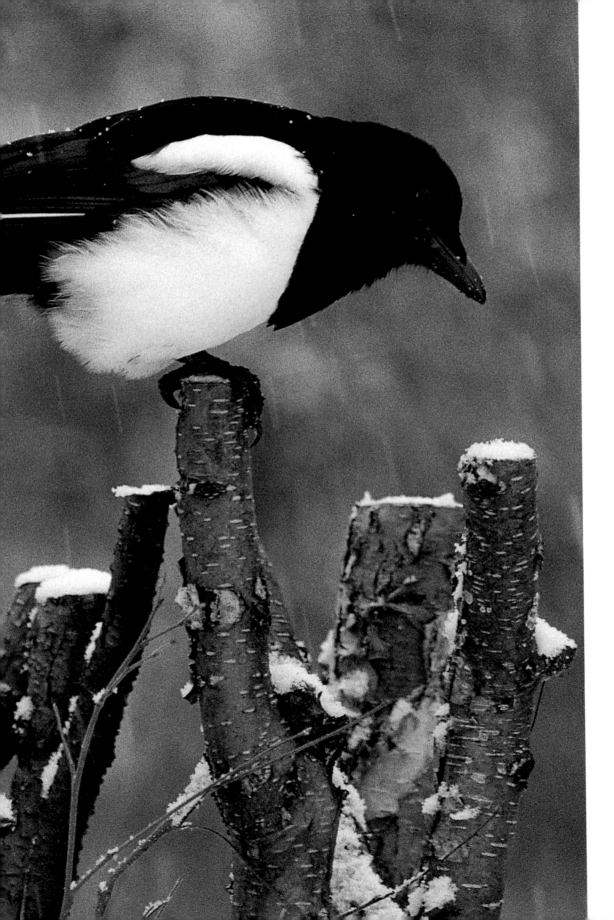

THE MAGPIE'S LONG TAIL

Once upon a time (or so we are told by a Finnish folk-tale), a too-talkative magpie informed a man that he would die within twenty-four hours. This brazen announcement was annoying to God, who grabbed the bird by its stubby tail and pulled its feathers. To this day, magpies have long, slender tails as a reminder of their effrontery.

Different modes of life call forth different modes of intelligence. Although magpies may not share the prodigious memories of jays and nutcrackers, they are remarkably observant and acute, powers that help to sustain them through the long, challenging months of midwinter.

TORBJÖRN LILJA,
NATURFOTOGRAFERNA/N

start during their first summer.

How do they do it? The answer seems to be that the birds remember the precise locations at which they placed each one of them. In a set of experiments conducted by the Dutch biologist I. Bossema, a group of Eurasian jays was placed in an aviary and allowed to hide acorns. When the birds were readmitted days or, in some cases, weeks later, each quickly located most of its own reserves. Yet when jays that had not hidden acorns in the room were permitted to enter, they did not find a single one of the buried items.

On the basis of his investigations, Bossema concluded that the jays remembered the position of their caches by taking a fix on the visual features of their environment, both near and far. Local landmarks, such as trees and fallen logs, served as excellent beacons for the hungry jays, unless they were obscured by snowfall. More distant features of the landscape, such as hillsides and streams, offered less precise sight lines but were unlikely to be altered by seasonal changes. By orienting themselves to both types of markers, the jays were able to remember thousands of pinpoint locations and return to them with superhuman aplomb.

The Nutcracker Never Forgets

The most compelling research into cache retrieval and memory in birds centres on another equally amazing member of the corvid family—the Clark's nutcracker. Close cousins of the Eurasian nutcrackers, these dapper grey birds are favourites with tourists, who enjoy feeding them by hand in the parks of the Rocky Mountains. When they're not plucking peanuts from the fists of sunburned hikers, Clark's nutcrackers spend their time harvesting seeds from pine cones. In one short summer season, a single nutcracker is estimated to cache between 22,000 and 33,000 seeds in up to 7,500 different

places. To survive the winter and spring, it must recover about a third of these tiny reserves, all of which are buried in loose soil. Although most caches are made on windswept ridges or south-facing slopes where the snow cover is light, nutcrackers have been known to unearth caches from drifts that lie hip deep.

So how do they do it? Again, the answer seems to lie in their prodigious memories. In laboratory tests, biologist Stephen Vander Wall found that nutcrackers, like Eurasian jays, were much more successful at finding their own caches (with a hit rate of 70 per cent) than those made by others (10 per cent). "Only the bird that prepares a cache has the necessary information to find it," he surmised. And what information is necessary? Vander Wall noticed that his birds often deposited seeds within a hand's width of a conspicuous object, such as a rock. When he shifted some of the objects in his aviary, the birds shifted their recovery probes by a comparable distance, as if they had plotted the position of their caches in relation to the visual features of their habitat.

The birds, it seemed, had drawn mental maps with such acuity that they could be used to locate tiny clusters of pine seeds buried somewhere in an aviary or, in nature, across a mountainside. Once formed, this complex memory, which summarized thousands of separate events, appeared to provide reliable guidance for up to eleven months.

If nutcrackers and jays form internal representations (mental maps) of external facts (their caching sites), then by definition they have *minds*. As the events of the outer world pass before their senses, the imagery of their inner world plays before their mind's eye. In the opinion of psychologist Stephen Walker, author of a landmark book, *Animal Thought*, this is precisely what brains are for. The main function of a highly developed nervous system, he proposes, "is to provide an internal model of reality" that corresponds to the world around us. "Ideas are necessary" to people

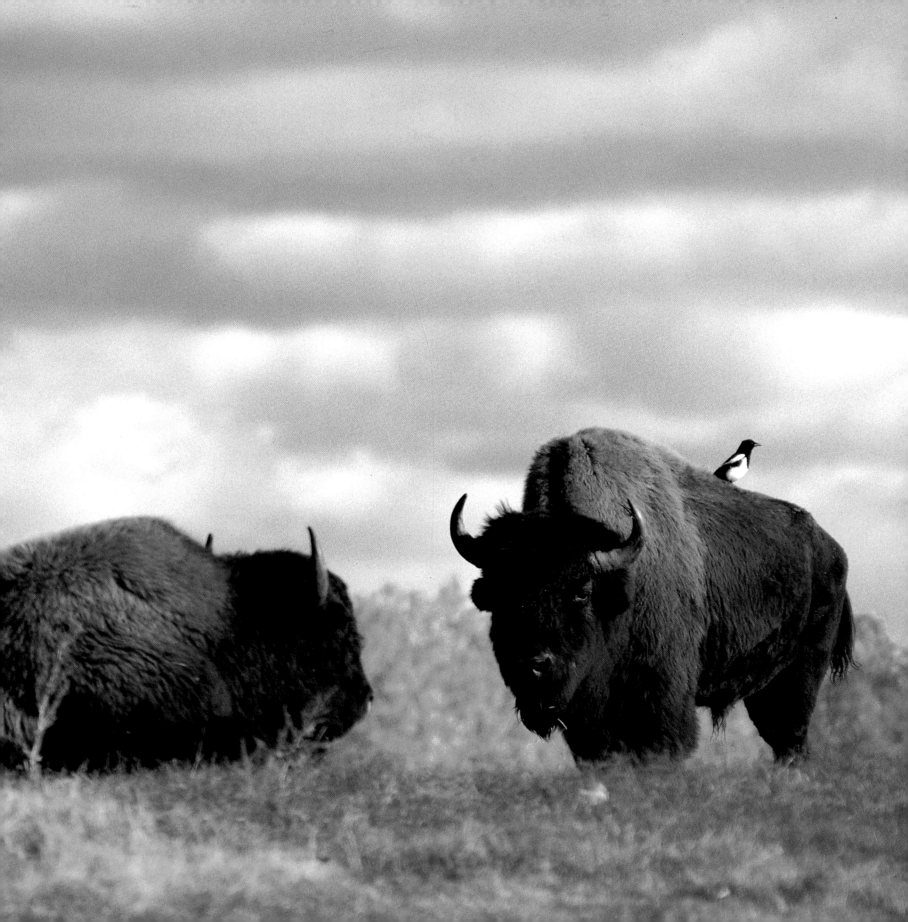

and animals, he says, "because they correspond to external reality." From the interaction of the two sources of information, inner and outer, the world takes on meaning—look for food here, not there—and the organism is able to decide what to do and to act purposefully on its decisions.

Cache retrieval is a simple win-lose problem: either the birds find the hidden food or they don't. This has made the subject amenable to rigorous, numerical investigation. Just count the hits and misses, and you're doing science. But many of the challenges that corvids face are more inscrutable. How do we know if a jay has chosen the best possible mate or if a crow is making the most energy-efficient choice of foods? How can we determine whether or not corvids think about these and other complex problems? How can we hope to glimpse their thoughts, if they have them?

Perhaps we will never attain hard and fast answers to these inviting questions. But that is neither reason nor excuse for disdaining them. We live in a world of wonders. In a universe that is so prodigal in its invention, why should we restrict ourselves to a few dried-out old ideas that clearly cannot do justice to our experience? The possibilities of nature, and of understanding, are not limited by the conventions of positivistic science. By their example, crows, ravens, magpies and jays call us to open our minds to the full possibilities of intelligence—our own as well as theirs.

Notes

Notes refer to direct quotations only. For a complete listing of sources, please consult the bibliography.

CHAPTER 1

Page 1, Rev. Henry Ward Beecher as quoted by John Madson, "The Dance on Monkey Mountain and Other Crow Doings," *Audubon* 78 (1976), 57.

Pages 2, 4, Benjamin B. Beck, *Animal Tool Behavior: The Use and Manufacture of Tools by Animals* (New York: Garland STPM Press, 1980), 29.

Pages 8–9, Edgar Allan Poe, "The Raven," in *Selected Writings of Edgar Allan Poe*, ed. Edward H. Davidson (Boston: Houghton Mifflin, 1956), 38.

Page 9, Lord Winstanley as quoted by T. R. Birkhead, *The Magpies: The Ecology and Behaviour of Black-Billed and Yellow-Billed Magpies* (London: T and A D Poyser, 1991), 221.

"The Three Crows," from Bertrand Harris Bronson, *The Traditional Tunes of the Child Ballads*, vol. 1 (Princeton,

N.J.: Princeton University Press, 1959), 313. Illustration from the British Library.

Page 16, John K. Terres, *The Audubon Society Encyclopedia of North American Birds* (New York: Alfred A. Knopf, 1980), 137.

Tony Angell, *Ravens, Crows, Magpies and Jays* (Vancouver: Douglas and McIntyre, 1978), 82.

Bernd Heinrich, *Ravens in Winter* (New York: Summit, 1989), 20.

Konrad Lorenz, *King Solomon's Ring: New Light on Animal Ways*, translated by Marjorie Kerr Wilson (London: Methuen, 1952), 89.

"Magpie Counting Rhyme," from Iona Opie and Moira Tatem, *A Dictionary of Superstitions* (Oxford: Oxford University Press, 1992), 236.

Page 18, Irene M. Pepperberg, "A Communicative Approach to Animal Cognition: A Study of Conceptual Abilities of an African Grey Parrot," in *Cognitive Ethology: The Minds of Other Animals*, edited by Carolyn A. Ristau (Hillsdale, N.J.: Lawrence Erlbaum Associates, 1991), 159–60.

Page 22, Lorenz, *King Solomon's Ring*, 141–42.

Page 26, Lorenz, *King Solomon's Ring*, 143.

Page 29, Re tradition: Lorenz, *King Solomon's Ring*, 145.

Re mosaic: Lorenz, *King Solomon's Ring*, 132.

Re learning abilities: Lorenz, "A Consideration of Methods of Identification of Species-Specific Instinctive Behaviour Patterns in Birds (1932)," in *Studies in Animal and Human Behaviour*, vol. 1, translated by Robert Martin (London: Methuen, 1971), 63.

"The Crow and the Pitcher," from V. S. Vernon Jones, trans., *Aesop's Fables* (London: Pan, 1975 [1912]), 23. Illustration by Richard Heighway, from Joseph Jacobs, ed., *The Fables of Aesop* (New York: Schocken, 1966 [1894]), 129.

CHAPTER 2

Page 32, Lorenz, *King Solomon's Ring*, 8.

Pages 40–41, Lorenz,

"Contributions to the Study of the Ethology of Social Corvidae (1931)," in *Studies in Animal and Human Behaviour*, vol. 1, 42.

"The Raven and the First People," from Bill Reid and Robert Bringhurst, *The Raven Steals the Light* (Vancouver: Douglas and McIntyre, 1984), 29.

Illustration from the University of British Columbia Museum of Anthropology.

Page 41, Derek Goodwin, *Crows of the World* (London: British Museum of Natural History, 1986), 80.

Pages 47–48, John M. Marzluff, "Do Pinyon Jays Alter Nest Placement Based on Prior Experience?" *Animal Behaviour* 36 (1988), 1, 2, 8.

Page 50, Heinrich, *Ravens in Winter*, 114.

Page 56, Lorenz, "Contributions to the Study of the Ethology of Social Corvidae (1931)," 49.

Deborah Buitron, "Variability in the Responses of Black-Billed Magpies to Natural Predators," *Behaviour* 87 (1983), 229.

Page 57, Carolee Caffrey, "Female-Biased Delayed Dispersal and Helping in American Crows," *Auk* 109 (1992), 617.

"The Raven and the Flood," from *The Babylonian Story of the Deluge and the Epic of Gilgamesh* (London: British Museum, 1920), 37.

Illustration from Edward H. Armstrong, *The Folklore of Birds* (London: Collins, 1958), 76.

Page 58, Alexander Skutch, *Helpers at Birds' Nests: A Worldwide Survey of Cooperative Breeding and Related Behavior* (Iowa City: University of Iowa Press, 1987), 125.

CHAPTER 3

Page 61, Lawrence Kilham, *The American Crow and the Common Raven* (College Station: Texas A and M University Press, 1989), 213.

Page 66, J. M. Marzluff and R. P. Balda, "Pinyon Jays: Making the Best of a Bad Situation by Helping," in *Cooperative Breeding in Birds: Long-Term Studies of Ecology and Behaviour*, ed. Peter B. Stacy and Walter D. Koenig (Cambridge: Cambridge University Press, 1990), 232, 233.

Page 70, "Why the Raven Is Black," based on Peter Goodchild, *Raven Tales: Traditonal Stories of Native Peoples* (Chicago: Chicago Review Press, 1991), 91.

Page 71, Millicent S. Ficken, "Avian Play," *Auk* 94 (1977), 578.

Page 75, Re Edgar: Heinrich, *Ravens in Winter*, 206.

Page 76, Re status: Heinrich, *Ravens in Winter*, 313.

Re airborne play: Heinrich, *Ravens in Winter*, 206–7.

Page 79, J. M. Marzluff and R. P. Balda, "The Advantages of, and Constraints Forcing, Mate Fidelity in Pinyon Jays," *Auk* 105 (1988), 293.

Page 80, Lorenz, *King Solomon's Ring*, 175.

Pages 80, 83, Re imitation: Konrad Lorenz, "A Consideration of Methods of Identification of Species-Specific Instinctive Behaviour Patterns in Birds (1932)," 77.

Page 83, Re human word: Lorenz, *King Solomon's Ring*, 91.

Goodwin, *Crows of the World*, 53.

Page 86, Re repertoire: Eleanor D. Brown, "The Role of Song and Vocal Imitation among Common Crows (*Corvus brachyrhynchos*)," *Zietschrift für Tierpsychologie* 68 (1985), 134.

Re feeding: Nicolaas A. M. Verbeek and Robert W. Butler, "Cooperative Breeding of the Northwestern Crow *Corvus caurinus* in British Columbia," *Ibis* 123 (1981), 186.

Page 87, Heinrich, *Ravens in Winter*, 246.

Page 88, "The Raven," from Edward H. Davidson, ed., *Selected Writings of Edgar Allen Poe* (Boston: Houghton Mifflin, 1956), 37–38.

Illustration from *Le Corbeau d'Edgar Poe* (Paris: Éditions L.C.L., 1969).

CHAPTER 4

Page 91, Donald R. Griffin, "Progress towards a Cognitive Ethology," in *Cognitive Ethology* (1991), 5.

Page 98, Reto Zach, "Shell Dropping: Decision-Making and Optimal Foraging in Northwestern Crows," *Behaviour* 68 (1979), 106.

Page 100, I. Bossema, "Jays and Oaks: An Eco-Ethological Study of a Symbiosis," *Behaviour* 78 (1970), 29.

Pages 100, 104, Re shell dropping: Zach, "Shell Dropping," 114, 115.

Page 108, Paul Sherman, as quoted by Heinrich, *Ravens in Winter*, 252.

"The Killing of Grizzly Bear," based on Goodchild, *Raven Tales*, 21, 57.

Page 117, "The Magpie's Long Tail," based on Stilth Thompson, *Motif-Index of Folk-Literature* (Helsinki: Soumalainen Tiedea Katemia Scientiarum Fennica, 1932), 209.

Page 120, Stephen B. Vander Wall, "An Experimental Analysis of Cache Recovery in Clark's Nutcracker," *Animal Behaviour* 30 (1982), 92.

Pages 120, 122, Stephen Walker, *Animal Thought* (London: Routledge and Kegan Paul, 1983), 113.

Bibliography

GENERAL

Angell, Tony. 1978. *Ravens, Crows, Magpies and Jays*. Vancouver: Douglas and McIntyre.

Birkhead, T. R. 1991. *The Magpies: The Ecology and Behaviour of Black-Billed and Yellow-Billed Magpies*. London: T and A D Poyser.

Gill, Frank B. 1990. *Ornithology*. New York: W. H. Freeman and Company.

Goodwin, Derek. 1986. *Crows of the World*. London: British Museum of Natural History.

Heinrich, Bernd. 1989. *Ravens in Winter*. New York: Summit.

Kilham, Lawrence. 1989. *The American Crow and the Common Raven*. College Station: Texas A and M University Press.

Lorenz, Konrad Z. 1952. *King Solomon's Ring: New Light on Animal Ways*. Translated by Marjorie Kerr Wilson. London: Methuen.

—. 1971. "A Consideration of Methods of Identification of Species-Specific Instinctive Behaviour Patterns in Birds (1932)." In *Studies in Animal and Human Behaviour*. Vol. 1, pp. 57–100. Translated by Robert Martin. London: Methuen.

—. 1971. "Contributions to the Study of the Ethology of Social Corvidae (1931)." In *Studies in Animal and Human Behaviour*. Vol. 1, pp. 1–56. Translated by Robert Martin. London: Methuen.

Marzluff, John. 1992. *Pinyon Jay: Behavioral Ecology of a Colonial and Cooperative Corvid*. San Diego: Academic Press.

Roëll, A. 1978. "Social Behavior of the Jackdaw, *Corvus monedula*, in Relation to Its Niche." *Behaviour* 64: 1–124.

CHAPTER 1

Armstrong, Edward A. 1958. *The Folklore of Birds*. London: St. James's Place.

Barber, Theodore Zenophon. 1993. *The Human Nature of Birds*. New York: St. Martin's.

Beck, Benjamin B. 1980. *Animal Tool Behavior: The Use and Manufacture of Tools by Animals*. New York: Garland STPM Press.

Bekoff, Marc, and Dale Jamieson. 1990. *Interpretation and Explanation in the Study of Animal Behavior*. Vol. 1. Boulder, Colo.: Westview Press.

Benjamini, Levy. 1983. "Studies in the Learning Abilities of Brown-Necked Ravens and Herring Gulls. I. Oddity Learning." *Behaviour* 84: 173–94.

Cooper, J. C. 1992. *Symbolic and Mythological Animals*. London: Aquarian.

Epstein, R., C. E. Kirshnit, R. P. Lanza, and L. C. Rubin. 1984. "'Insight' in the Pigeon: Antecedents and Determinants of an Intelligent Performance." *Nature* 308: 61–62.

Goodchild, Peter. 1991. *Raven Tales: Traditional Stories of Native Peoples*. Chicago: Chicago Review Press.

Gossette, Robert L. 1967. "Successive Discrimination Reversal (SDR) Performances of Four Avian Species on a Brightness Discrimination Task." *Psychonomic Science* 8(1): 17–18.

Gossette, Robert L., Madeleine Frome Gossette, and William Riddell. 1966. "Comparisons of Successive Discrimination Reversal Performances among Closely and Remotely Related Avian Species. " *Animal Behaviour* 14: 560–64.

Griffin, Donald R. 1984. *Animal Thinking*. Cambridge, Mass.: Harvard University Press.

—. 1992. *Animal Minds*. Chicago: University of Chicago Press.

Madson, John. 1976. "The Dance on Monkey Mountain and Other Crow Doings." *Audubon* 78: 52–61.

Merkur, Daniel. 1991. *Powers Which We Do Not Know: The Gods and Spirits of the Inuit*. Moscow: University of Idaho Press.

Nelson, Richard K. 1983. *Make Prayers to the Raven: A Koyukon View of the Northern Forest*. Chicago: University of Chicago Press.

Pepperberg, Irene M. 1991. "A Communicative Approach to Animal Cognition: A Study of Conceptual Abilities of an African Grey Parrot." In *Cognitive Ethology: The Minds of Other Animals*, edited by Carolyn A. Ristau. Hillsdale, N.J.: Lawrence Erlbaum Associates.

—. 1994. "Vocal Learning in Grey Parrots (*Psittacus erithacus*): Effects of Social Interaction, Reference, and Context." *Auk* 111: 300–313.

Powell, Robert W. 1972. "Operant Conditioning in the Common Crow (*Corvus brachyrhynchos*)." *Auk* 89: 738–42.

Radner, Daisie, and Michael Radner. 1989. *Animal Consciousness*. New York: Prometheus Books.

Ramsay, A. O. 1950. "Conditioned Responses in Crows." *Auk* 67: 456–59.

Ristau, Carolyn A., ed. 1991. *Cognitive Ethology: The Minds of Other Animals*. Hillsdale, N.J.: Lawrence Erlbaum Associates.

Stettner, Laurence Jay, and Kenneth A. Matyniak. 1968. "The Brain of Birds." *Scientific American* 218: 64–76.

Stone, Eric, and Charles H. Trost. 1991. "The Effects of Supplemental Food on Nest Dispersion in Black-Billed Magpies." *Condor* 93: 452–54.

Terres, John K. 1980. *The Audubon Society Encyclopedia of North American Birds*. New York: Alfred A. Knopf.

CHAPTER 2

Balda, Russell P., and Gary C. Bateman. 1972. "The Breeding Biology of the Pinon Jay." *Living Bird* 11: 5–42.

Barg, Jennifer J., and Ronald L. Mumme. 1994. "Parental Recognition of Juvenile Begging Calls in the Florida Scrub Jay." *Auk* 111: 459–64.

Buitron, Deborah. 1983. "Variability in the Responses of Black-Billed Magpies to Natural Predators." *Behaviour* 87: 209–36.

—. 1988. "Female and Male Specialization in Parental Care and Its Consequences in Black-Billed Magpies." *Condor* 90: 29–39.

Burt, D. Brent, and A. Townsend Peterson. 1993. "Biology of

Cooperative-Breeding Scrub Jays (*Aphelocoma coerulescens*) of Oaxaca, Mexico." *Auk* 110: 207–14.

Caffrey, Carolee. 1992. "Female-Biased Delayed Dispersal and Helping in American Crows." *Auk* 109: 609–19.

Curio, E., U. Ernst, and W. Vieth. 1978. "Cultural Transmission of Enemy Recognition: One Function of Mobbing." *Science* 202: 899–901.

D'Agostino, Gloria M., Lorraine E. Giovinazzo, and Stephen W. Eaton. 1981. "The Sentinel Crow as an Extension of Parental Care." *Wilson Bulletin* 93: 394–95.

Lawrence, Louise de Kiriline. 1947. "Five Days with a Pair of Nesting Canada Jays." *Canadian Field-Naturalist* 61: 1–11.

Ligon, J. David. 1991. "Cooperation and Reciprocity in Birds and Mammals." In *Kin Recognition*, edited by Peter G. Hepper, pp. 30–59. Cambridge: Cambridge University Press.

McArthur, Patrick D. 1982. "Mechanisms and Development of Parent-Young Vocal Recognition in the Pinon Jay." *Animal Behaviour* 30: 62–74.

Marzluff, John M. 1988. "Do Pinyon Jays Alter Nest Placement Based on Prior Experience?" *Animal Behaviour* 36: 1–10.

Marzluff, J. M., and R. P. Balda. 1990. "Pinyon Jays: Making the Best of a Bad Situation by Helping." In *Cooperative*

Breeding in Birds: Long-Term Studies of Ecology and Behaviour, edited by Peter B. Stacy and Walter D. Koenig, pp. 197–238. Cambridge: Cambridge University Press.

———. 1992. *The Pinion Jay: Behavioural Ecology of a Colonial and Cooperative Corvid.* London: T & AD Poyser.

Redondo, Tomas, and Francisca Castro. 1992. "Signalling of Nutritional Need by Magpie Nestlings." *Ethology* 92: 193–204.

Skutch, Alexander F. 1987. *Helpers at Birds' Nests: A Worldwide Survey of Cooperative Breeding and Related Behavior.* Iowa City: University of Iowa Press.

Stacey, Peter B., and Walter D. Koenig, eds. 1990. *Cooperative Breeding in Birds: Long-Term Studies of Ecology and Behaviour.* Cambridge: Cambridge University Press.

Woolfender, G. E., and J. W. Fitzpatrick. 1984. *The Florida Scrub Jay: Demography of a Cooperative-Breeding Bird.* Princeton, N.J.: Princeton University Press.

———. 1990. "Florida Scrub Jays: A Synopsis After 18 Years of Study." In *Cooperative Breeding in Birds: Long-Term Studies of Ecology and Behaviour*, edited by Peter B. Stacy and Walter D. Koenig, pp. 239–66. Cambridge: Cambridge University Press.

CHAPTER 3
Bradley, Charles C. 1978. "Play Behavior in Northern Ravens." *Passenger Pigeon* 40: 493–95.

Bright, Michael. 1984. *Animal Language.* London: British Broadcasting Corporation.

Brown, Eleanor D. 1985. "The Role of Song and Vocal Imitation among Common Crows (*Corvus brachyrhynchos*)." *Zietschrift für Tierpsychologie* 68: 115–36.

Brown, J. R., and E. R. Brown. 1990. "Mexican Jays: Uncooperative Breeding." In *Cooperative Breeding in Birds: Long-Term Studies of Ecology and Behaviour*, edited by Peter B. Stacy and Walter D. Koenig, pp. 267–88. Cambridge: Cambridge University Press.

Chamberlain, Dwight R., and George W. Cornwell. 1971. "Selected Vocalizations of the Common Crow." *Auk* 88: 613–34.

Elston, Catherine Feher. 1991. *Ravensong: A Natural and Fabulous History of Ravens and Crows.* Flagstaff, Ariz.: Northland.

Ficken, Millicent S. 1977. "Avian Play." *Auk* 94: 573–82.

Frings, Hubert, and Mable Frings. 1959. "The Language of Crows." *Scientific American* 201 (5): 119–31.

Heinrich, Bernd, Delia Kaye, Ted Knight, and Kristin Schaumburg. 1994. "Dispersal and Association among Common Ravens." *Condor* 96: 545–51.

Heinrich, Bernd, John M. Marzluff, and Colleen S. Marzluff. 1993. "Common Ravens Are Attracted by

Appeasement Calls of Food Discoverers When Attacked." *Auk* 110: 247–54.

Johnson, Kristine. 1988. "Sexual Selection in Pinyon Jays I: Female Choice and Male-Male Competition." *Animal Behaviour* 36: 1038–47.

——. 1988. "Sexual Selection in Pinyon Jays II: Male Choice and Female-Female Competition." *Animal Behaviour* 36: 1048–53.

Marzluff, John M. 1988. "Vocal Recognition of Mates by Breeding Pinyon Jays, *Gymnorhinus cyanocephalus*." *Animal Behaviour* 36: 296–98.

Marzluff, J. M., and R. P. Balda. 1988. "The Advantages of, and Constraints Forcing, Mate Fidelity in Pinyon Jays." *Auk* 105: 286–95.

——. 1988. "Pairing Patterns and Fitness in a Free-Ranging Population of Pinyon Jays: What Do They Reveal about Mate Choice?" *Condor* 90: 201–13.

——. 1990. "Pinyon Jays: Making the Best of a Bad Situation by Helping." In *Cooperative Breeding in Birds: Long-Term Studies of Ecology and Behaviour*, edited by Peter B. Stacy and Walter D. Koenig, pp. 197–238. Cambridge: Cambridge University Press.

Slobodchikoff, C. N. 1988. *The Ecology of Social Behavior*. San Diego: Academic Press.

Steihl, Richard B. 1981. "Observations of a Large Roost of

Common Ravens." *Condor* 83: 78.

Van Vuren, Dirk. 1984. "Aerobatic Rolls by Ravens on Santa Cruz Island, California." *Auk* 101: 620–21.

Verbeek, Nicolaas A. M., and Robert W. Butler. 1981. "Cooperative Breeding of the Northwestern Crow *Corvus caurinus* in British Columbia. *Ibis* 123: 183–89.

CHAPTER 4
Balda, Russell P., and Alan C. Kamil. 1989. "A Comparative Study of Cache Recovery by Three Corvid Species." *Animal Behaviour* 38: 486–95.

Balda, Russell P., and Richard J. Turek. 1984. "The Cache-Recovery System As an Example of Memory Capabilities in Clark's Nutcracker." In *Animal Cognition*, edited by H. L. Roitblat et al., pp. 513–32. Hillsdale, N.J.: Lawrence Erlbaum Associates.

Balda, Russell P., and Wolfgang Wiltschko. 1991. "Caching and Recovery in Scrub Jays: Transfer of Sun-Compass Directions from Shaded to Sunny Areas." *Condor* 93: 1020–23.

Beck, Benjamin B. 1986. "Tools and Intelligence." In *Animal Intelligence: Insights into the Animal Mind*, edited by R. J. Hoage and Larry Goldman, pp. 135–47. Washington, D.C.: Smithsonian Institution Press.

Bossema, I. 1979. "Jays and Oaks: An Eco-Ethological Study of a Symbiosis." *Behaviour* 70: 1–117.

Buitron, Deborah, and Gary L.

Nuechterlein. 1985. "Experiments on Olfactory Detection of Food Caches by Black-Billed Magpies." *Condor* 87: 92–95.

Croze, Harvey J. 1970. "Searching Images in Carrion Crows." *Zietschrift für Tierpsychologie Beiheft* 5.

Dow, Douglas D. 1965. "The Role of Saliva in Food Storage by the Gray Jay." *Auk* 82: 139–54.

Erikstad, Kjell Einar, Roar Blom, and Svein Myrberget. 1982. "Territorial Hooded Crows as Predators on Willow Ptarmigan Nests." *Journal of Wildlife Management* 46: 109–14.

Gayou, Douglas C. 1982. "Tool Use by Green Jays." *Wilson Bulletin* 94: 593–94.

Grobecker, David B., and Theodore W. Pietsch. 1978. "Crows Use Automobiles As Nutcrackers." *Auk* 95: 760–61.

Harrington, Fred H. 1978. "Ravens Attracted to Wolf Howling." *Condor* 80: 236–37.

Heinrich, Bernd. 1988. "Raven Tool Use?" *Condor* 90: 270–71.

James, Paul C.; and Nicolaas A. M. Verbeek. 1983. "The Food Storage Behaviour of the Northwestern Crow." *Behaviour* 85: 276–91.

Janes, Stewart W. 1976. "The Apparent Use of Rocks by a Raven in Nest Defense." *Condor* 78: 409–23.

Johnson, W. Carter, and Curtis S.

Adkisson. 1984. "Dispersal of Beech Nuts by Blue Jays in Fragmented Landscapes. *American Midland Naturalist* 113: 319–24.

Jones, Thony B., and Alan C. Kamil. 1973. "Tool-Making and Tool-Using in the Northern Blue Jay." *Science* 180: 1076–77.

Kamil, Alan C. 1985. "The Ecology of Foraging Behavior: Implications for Animal Learning and Memory." *Annual Review of Psychology* 36: 141–69.

Kamil, Alan C., and Russell P. Balda. 1985. "Cache Recovery and Spatial Memory in Clark's Nutcrackers (*Nucifraga columbiana*)." *Journal of Experimental Psychology: Animal Behavior Processes* 11: 95–111.

———. 1990. "Spatial Memory in Seed-Caching Corvids." In *The Psychology of Learning and Motivation.* Vol. 26, pp. 1–25. San Diego: Academic Press.

Kamil, Alan C., and Theodore D. Sargent. 1981. *Foraging Behavior: Ecological, Ethological, and Psychological Approaches.* New York: Garland STPM Press.

Krebs, J. R., and N. B. Davies. 1991. *Behavioural Ecology: An Evolutionary Approach.* Oxford: Blackwell Scientific.

Michener, Harold, and Josephine R. Michener. 1945. "California Jays, Their Storage and Recovery of Food, and Observations at One Nest." *Condor* 47: 206–10.

Montevecchi, William A. 1976. "Egg Size and the Egg Predatory

Behaviour of Crows." *Behaviour* 57: 307–20.

Picozzi, N. 1975. "Crow Predation on Marked Nests." *Journal of Wildlife Management* 39: 151–55.

Reid, James B. 1982. "Tool-Use by a Rook (*Corvus frugilegus*), and Its Causation." *Animal Behaviour* 30: 1212–16.

Shettleworth, Sara J. 1983. "Memory in Food-Hoarding Birds." *Scientific American* 248(3): 102–11.

Thorpe, W. H. 1969. *Learning and Instinct in Animals.* Cambridge, Mass.: Harvard University Press.

Tomback, Diana F. 1980. "How Nutcrackers Find Their Seed Stores." *Condor* 82: 10–19.

———. 1983. "Nutcrackers and Pines: Coevolution and Coadaption?" In *Coevolution,* edited by Matthew H. Nitecki, pp. 179–224. Chicago: University of Chicago Press.

Turcek, Frantisek J., and Leon Kelso. 1968. "Ecological Aspects of Food Transportation and Storage in the Corvidae." *Communications in Behavioral Biology,* Part A 1: 277–97.

Vander Wall, Stephen B. 1982. "An Experimental Analysis of Cache Recovery in Clark's Nutcracker." *Animal Behaviour* 30: 84–94.

———. 1990. *Food Hoarding in Animals.* Chicago: University of Chicago Press.

Vander Wall, Stephen B., and Russell P. Balda. 1981. "Ecology and Evolution of Food-Storage Behavior

in Conifer-Seed-Caching Corvids." *Zietschrift für Tierpsychologie* 56: 217–42.

Waite, Thomas A., and John D. Reeve. 1993. "Food Storage in Gray Jays: Source Type and Cache Dispersion." *Ethology* 93: 326–36.

Waite, T. A., and R. C. Ydenberg. 1994. "What Currency Do Scatter-Hoarding Gray Jays Maximize?" *Behavioral Ecology and Sociobiology* 34: 43–49.

Walker, Stephen. 1983. *Animal Thought.* London: Routledge and Kegan Paul.

———. 1987. *Animal Learning: An Introduction.* London: Routledge and Kegan Paul.

Zach, Reto. 1978. "Selection and Dropping of Whelks by Northwestern Crows." *Behaviour* 67: 134–48.

———. 1979. "Shell Dropping: Decision-Making and Optimal Foraging in Northwestern Crows." *Behaviour* 68: 106–17.

Index